MEDIEVAL
CHURCH
ARCHITECTURE

Jon Cannon

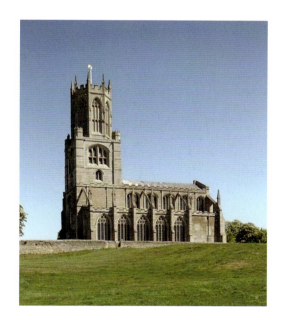

SHIRE PUBLICATIONS

SHIRE PUBLICATIONS
Bloomsbury Publishing Plc

Kemp House, Chawley Park, Oxford OX2 9PH, UK
1385 Broadway, 5th Floor, New York, NY 10018, USA
29 Earlsfort Terrace, Dublin 2, Ireland

SHIRE is a trademark of Osprey Publishing, a division of Bloomsbury Publishing Plc – shire@bloomsbury.com

© 2014 Jon Cannon

First published in Great Britain in 2014 by
Shire Publications

All rights reserved. Apart from any fair dealing for the purpose of private study, research, criticism or review, as permitted under the Copyright, Designs and Patents Act, 1988, no part of this publication may be reproduced, stored in a retrieval system, or transmitted in any form or by any means, electronic, electrical, chemical, mechanical, optical, photocopying, recording or otherwise, without the prior written permission of the copyright owner. Enquiries should be addressed to the Publishers.

Every attempt has been made by the Publishers to secure the appropriate permissions for materials reproduced in this book. If there has been any oversight we will be happy to rectify the situation and a written submission should be made to the Publishers.

A CIP catalogue record for this book is available from the British Library.

Shire Library no. 718 ISBN-13: 978 0 74781 212 8
PDF eBook ISBN: 978 0 74781 533 4
ePub ISBN: 978 0 74781 532 7

Jon Cannon has asserted his right under the Copyright, Designs and Patents Act, 1988, to be identified as the author of this book.

Designed by Tony Trucott Designs, Sussex, UK
Typeset in Perpetua and Gill Sans.
Printed and bound in India by Replika Press Private Ltd.

21 22 23 24 25 10 9 8 7 6 5

COVER IMAGE
Cover design and photography by Peter Ashley. Front cover: Perpendicular-style capitals and other details at Ripon Cathedral, after 1502. Back cover: Twelfth-century corbel grotesque at Kilpeck church, Herefordshire.

TITLE PAGE IMAGE
Fotheringhay church, Northamptonshire, built in the Perpendicular style in 1434 for Richard, Duke of York.

DEDICATION
To all my students, especially Dave Evans, whose idea this book was.

ACKNOWLEDGEMENTS
Photograph copyright is acknowledged as follows:
Alamy, page 60; Steve Cadman, page 66; Rex Harris, page 39 (bottom); Simon D. Jenkins, page 21; Roy Reed, page 70 (bottom); Shutterstock, page 50.

All remaining photographs are © copyright Jon Cannon, with grateful thanks to: the Dean and Chapter of Bristol Cathedral, for pages 18, 28 and 58; the Vicar of St Mary Redcliffe, for page 51; the Dean and Chapter of Exeter Cathedral, for pages 50, 57 and 59; reproduced by kind permission of Chichester Cathedral, page 27; and reproduced with kind permission of the Governing Body of Westminster School, page 81. Linework is from F. Mackenzie, *The Architectural Antiquities of the Collegiate Chapel of St Stephen, Westminster*, London, 1844, with kind permission of the Society of Antiquaries of London, page 63; Matthew Holbeche Bloxam, *The Principles of Gothic Ecclesiastical Architecture*, London, 1845, pages 72 and 82; John Henry Parker, An ABC of *Gothic Architecture*, Oxford, 1913, page 42 and 58. Textual quotes: Hugh of Avranches, as translated by Charles Garton, *The Metrical Life of St Hugh*, Honeywood Press, 1986; John Leland, quoted by Christopher Wilson in Richard Marks and Paul Williamson (editors), *Gothic: Art for England 1400–1547*, Victoria and Albert Museum, 2003; John Lydgate, *Troy Book* (book II), in Henry Bergen (editor), Early English Text Society, 1906, spelling modernised.

Shire Publications is supporting the Woodland Trust, the UK's leading woodland conservation charity, by funding the dedication of trees.

CONTENTS

INTRODUCTION	4
ANGLO-SAXON	14
NORMAN OR ROMANESQUE	18
THE BIRTH OF GOTHIC: TRANSITIONAL	26
GOTHIC I: EARLY ENGLISH	34
GOTHIC II: DECORATED	46
GOTHIC III: PERPENDICULAR	60
POSTSCRIPT	79
GLOSSARY	81
FURTHER READING	89
PLACES TO VISIT	90
APPENDIX: CHRONOLOGY OF STYLES	93
INDEX	94

INTRODUCTION

Churches were the most ambitious buildings in the medieval landscape. Their designers aimed to provide an appropriate architectural setting for a sacred and theatrical liturgy and a glimpse of what heaven might be like. In pursuit of these goals a restless search took place for new architectural effects. As a result, the architectural motifs they used constantly evolved. These details tend to develop in broad phases known as styles, each with its own distinctive overall aesthetic quality. Knowledge of these styles can be extremely rewarding, enabling one to better appreciate these beautiful works of architectural art; to give an approximate date to entire buildings and parts of buildings; and to understand them better as monuments to the changing times and tastes of the distant past.

The aim of this book is to enable beginners to recognise these styles as they appear in England. To this end, I pick out in particular those details that are most foolproof and easy to remember, and that can thus be described as diagnostic when identifying a given style, while paying less attention to those that are harder to distinguish from each other. Learn these, and you are halfway there. The most straightforwardly diagnostic elements are often ornamental: the way foliage is carved, for example, or the patterns of **tracery** seen in windows. Other features, such as the shapes of **arches** and the stone patterns made in roof **vaults**, are also helpful for diagnosis; the **mouldings** with which all these things are articulated can, by contrast, be challenging for the beginner, and only the more straightforwardly diagnostic developments are addressed here. Indeed, some very simple mouldings are possible at any period. Definitions of technical terms, picked out in **bold** when they are first used in the text, will be found in the glossary where they are not self-explanatory.

These stylistic phases were first identified in 1817 by Thomas Rickman, and the names he gave them – for the **Gothic** era, **Early English** (EE), **Decorated** (Dec) and **Perpendicular** (Perp) – remain widely used. However, the masons who created these buildings were living in the present

moment, as we do, simply attempting to create the most up-to-date and impressive buildings they could. They would not have recognised our stylistic categories, which depend on over five hundred years of hindsight. So a final and subsidiary aim of this book is to give the reader a sense of how these styles evolved 'in the present'.

I also attempt to describe the overall 'feel' of a style, for the process of identification has a subjective dimension. Apparently subtle changes of detail can have a marked influence on the stylistic effect of a building, and the way in which motifs are used – the context of other forms with which they sit – can be as diagnostic as the naming of individual motifs in isolation. One needs to develop a sense of the flavour of a style.

TIME AND DATE

It is a myth that it took centuries to build a medieval church. A small parish church took only a few years to build and usually went up in a single campaign, whereas a **cathedral** could be constructed in forty to sixty years. But progress might be halted in mid-build if funds ran out or wider events intervened. The longer such interruptions lasted, the more likely they were to have a visible impact on the design of the building.

Individual parts of any church might be rebuilt, or new parts added, however, and, when this happened, the style then current was usually followed. Windows (as well as tombs and other fittings) might be inserted into ancient walls, making a structure appear younger than it really is.

As a result, an old church might have developed over a long time, reaching its current form in a complex process that is intellectually stimulating to unravel. Ultimately this story can be fully understood only by studying any surviving documentary evidence and by bringing to bear a type of structural analysis known as buildings archaeology. This seeks to identify disjunctures in the fabric of a building, such as blocked arches or signs of one wall having been joined to another, and to study them to see

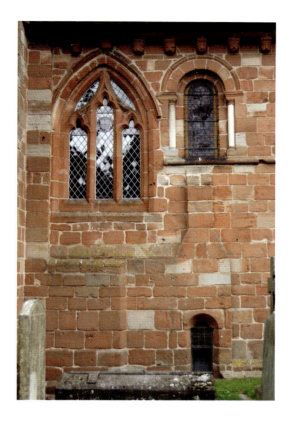

Two Norman windows at Berkswell, West Midlands, mark this church out as twelfth-century Norman; in the fourteenth century, a window in the Decorated style was inserted into the same wall. Such collisions of style and date give old churches a distinctive character and charm.

whether they can be interpreted stratigraphically, that is, whether one part can be proved to be older than another. No matter how persuasive the stylistic or documentary evidence, the story it tells is likely to be flawed if it is contradicted by the stratigraphy of the structure itself. This important subject is beyond the scope of this book, but a list of further reading can be found at the end.

The dates given for the architectural styles in this book should be treated as rules of thumb. Ten years' variance either side should be allowed for any date given as a *circa* (*c.*), for example, and one should be aware that an individual building may not fit the stylistic categories straightforwardly. In general, however, large ambitious buildings – **great churches**, see below, page 9 – as well as those smaller churches that happen to have been funded by exceptionally well-connected patrons, tend to be progressive, displaying early use of new motifs; out-of-date styles hold on longest in poor or isolated locations. But major buildings are also those for which documentary evidence of dating most often survives, and our chronologies have thus depended disproportionately on them. Some masons held on to old motifs (or even, on occasion, deliberately evoked the architecture of the past, or developed hard-to-classify new ideas); and in some parts of the country a given stylistic innovation might be ignored (see page 65). Exceptions to the rule are thus always possible. To confuse things further, Victorian restorers could produce deft, but misleading, versions of medieval style (see page 78).

In spite of this, the system outlined in these pages works surprisingly well. The science of dendrochronology is supplying us with accurate dates for ancient timbers used in smaller or undocumented buildings, and tends to confirm the accuracy of the broad stylistic phases that have been recognised for almost two hundred years.

CHURCH PLANS

It is essential to understand the plan of a church early in the process of exploring it. Though it rarely provides diagnostic dating information in its own right (for exceptions, see pages 16, 21 and 31), a church's plan helps orientate the viewer and reveals much about a building's development.

Almost all church buildings in England are axial, that is, they are longer than they are broad. The long axis runs east, towards the **high altar**, which is the building's *raison d'être*. The arm of the church that contains this altar is thus called the **east end**, though its

This parish church plan combines cruciform and basilican elements. Only the high altar is shown, but in the medieval period there would have been many more: a chapel in each transept, an altar in front of the screen which divided nave from chancel, and often others, too. The narrow windows in the chancel, the element sticking out to the right, suggest that it is the oldest part of this church. In this church, the tower might have risen over the centre of the building.

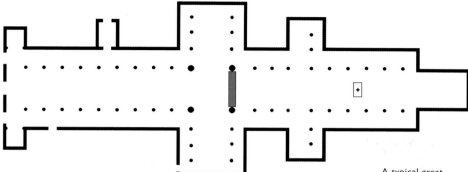

A typical great-church plan, combining axial and cruciform elements on a grand scale, with towers over the centre and at the west end, as well as a complex east end. A substantial stone screen, the pulpitum, separates choir from nave and transepts. As with the parish church, there are many side-altars, but here a dozen or so are set in separate chapels, positioned along the east-facing walls of the transepts and east end. No two buildings are the same, and not all have every feature shown here; in Romanesque great churches, screens are sometimes used to extend the space in which the choir sits under the crossing and some distance into the nave. The area west of the crossing is often still called the choir, though strictly speaking most of it will be the presbytery.

constituent parts have various names. Other parts are named accordingly: north and south **transepts**, north and south **aisles**, **west front**.

At its simplest, such a building may be merely a box, subdivided by an arch or a screen so that the area containing the altar, in this situation called the **chancel** (with the area immediately around the altar known as the **sanctuary**), is separated from the larger space, the **nave**. Such two-celled plans may suggest an early date and warn the observer to look for **Anglo-Saxon** or **Romanesque** (also known as **Norman**) features, especially if the chancel has a semicircular end, an **apse** (see page 21), which is almost always Anglo-Saxon or Norman in date.

Two more complex plans are also common: the most frequently encountered is known as **basilican** after the Roman meeting-halls used as a model for early Christian churches. Here, aisles run on both sides of the nave, and sometimes extend either side of the chancel, either stopping part-way down it or extending as far as its eastern wall. Altars usually stood at the end of each of these as well as in other parts of the building.

Roman basilicas usually had an apse at the end of the main central space, explaining the early popularity of apsidal chancels. Their aisles were separated from the central space by rows of vertical **columns**, which by the Christian era supported arches, forming **arcades**. Turning briefly to the resulting **elevation** of the interior, the central space, often called the **central vessel**, was usually higher than the side aisles, so as to create space for **clerestory** windows: each arch had a window above it, the two together comprising a **bay**. This is the basic architectural unit of the interior of a church building.

The next most common plan-type is known as **cruciform** because a north–south arm called a transept cuts across the central east–west vessel of nave and chancel, resulting in a cross-shaped plan, with altars against the east wall of each transept. If these transepts are very long and there are no aisles, this type of plan is almost centralised – that is, the

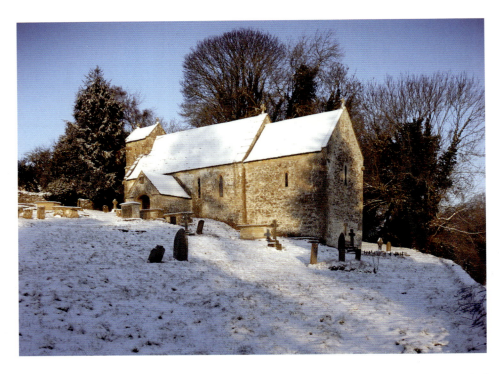

Duntisbourne Rouse, Gloucestershire, is a two-cell building with a stumpy tower and a porch at the west end. Most of this simple building was constructed at one time, probably in the late Anglo-Saxon or early Norman period.

focus of the plan is in the middle of the church rather than at the end of one axis. However, the main altar was always at the end of the east–west axis, and this almost always predominates architecturally: the most truly centralised medieval churches in England are circular, and even these had a chancel extending from one side.

The grandest churches often combine cruciform and basilican forms, combining them with a range of other features. The transept may have an aisle or aisles; there may be a second set of transepts further east, part of an east end that, in such buildings, can be very complex. Here, there will be many side-chapels, grouped in a variety of ways around the high altar (see page 7), and, along the main axis, such elements as (from east) a **Lady Chapel**; a hall-like **retrochoir** or **ambulatory** aisle; a **feretory**; a **presbytery**/sanctuary; and a **choir**. Such churches are often distinguished architecturally from ordinary parish churches by being called great churches.

GREATER AND LESSER CHURCHES

There is a hierarchical quality to medieval art, vividly illustrated by the idea of the 'great church'. It is important to be familiar with this concept as, in

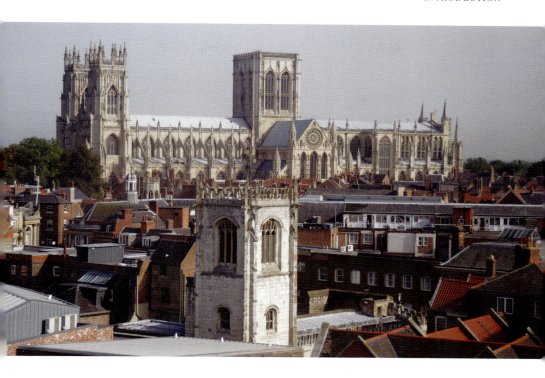

York Minster reached its current form in stages, resulting in a building with major works of the Early English, Decorated and Perpendicular periods. With three towers and a set of eastern transepts, and a combined cruciform and aisled (or basilican) plan, it is emphatically a great church.

addition to the elements of their plans just mentioned, a great many stylistic motifs and other architectural features are most commonly seen in these churches, which in any case usually led the way in terms of the invention and dissemination of new motifs. It also helps make sense of the vast panoply of structures with which one is faced.

The term 'great church' describes a range of architectural attributes that were possessed only by those churches that were home to wealthy religious institutions: in other words, the cathedrals (a church that is the seat of a bishop; such churches were also home to a community of monks or priests), as well as the larger **monastic** churches (inhabited by monks or nuns) and **collegiate** churches (the base for a community of priests). The architectural template for the great church developed over time (see pages 21, 31 and 74), but by about 1200 – that is, the dawn of the Gothic era – such buildings possessed or aspired to possess, in addition to a complex plan, stone vaults that covered the interior spaces of the entire church, and three-storey internal elevations, with an arcade at the lowest level, a **gallery** or **triforium** in the middle, and an upper clerestory. These were arranged into complex architectural compositions by the use of arches, mouldings, **attached shafts** and carved decorations. They also

MEDIEVAL CHURCH ARCHITECTURE

had complex east ends (see above, pages 7–8); elaborate **façades**, especially on the west fronts; and more than one tower (typically, two at the west end and one at the centre). While not every great church possessed all these features, many did, and most others had at least two or three of them. Great churches were

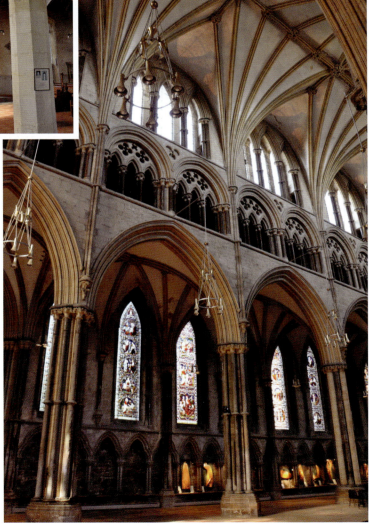

With its niches for statues and clerestory windows of alternating design, the elevation of the Decorated-era church at Cley next the Sea, Norfolk (left), is unusually elaborate for a parish church. Yet it could never be confused with Lincoln Cathedral (right), with its blank wall arcades, three-storeyed elevation and stone vaults.

usually designed by top-flight master masons who travelled widely in their work.

Parish churches possessed a very different character from great churches. This was the case even when their designer was clearly *au fait* with the latest ideas (he may indeed have come from a great-church workshop), or the church itself very large and elaborate; I have here sometimes called them **'lesser churches'**. In these buildings, stone vaults are rarely seen (if there are any, they will be in the tower, the entrance porch or the east end); and the internal elevation has at most two storeys: a clerestory and an arcade. The resulting composition is usually simple: a well-designed arcade with a row of windows above. The east end is also simple: a chancel, and chapels at the east end of any aisles. Façades are rarely elaborated and there is only one tower (sometimes at the west end, sometimes in the centre of the building, over the space between the transepts, or **crossing**).

In England, this window at St Nicholas, Galway would be called Curvilinear and dated to the 1330s–40s. But late medieval Scottish and Irish designers largely ignored English fashions, and this window is in fact early sixteenth century in date.

Originally the distinction between greater and lesser churches was not as clear-cut as it is now. A huge number of smaller and mid-ranking monastic houses sat on a scale between the two poles, but these have been lost in disproportionate numbers. Some (Temple Church, London, is an example) created sophisticated great-church architecture, but on a small scale; others (such as Dorchester Abbey, Oxfordshire) made episodic attempts at work of great-church character, but could not afford to sustain such efforts, resulting in memorably idiosyncratic buildings. Nevertheless, that an architectural 'glass ceiling' indeed existed is demonstrated by the fact that, though more than eight thousand medieval parish churches have survived in England alone, only one – St Mary Redcliffe, Bristol – was built purely as a parish church and yet possesses almost all the defining features of a great church. Other medieval parish churches with great-church attributes were almost always originally the base of a religious community, and are often called 'abbey', 'priory' or 'minster' to this day. Likewise, some buildings that are today cathedrals were not built as such: for example, the cathedrals of Gloucester and Newcastle were originally a top-flight medieval monastery and a parish church respectively, and their architectural character reflects their original status rather than their current one: Gloucester is the equal of

MEDIEVAL CHURCH ARCHITECTURE

any cathedral; Newcastle has the very different character of a large urban parish church.

DECORATION AND ICONOCLASM

All these buildings looked very different in the Middle Ages. To most medieval people, bare, unpainted stone surfaces looked unfinished. Churches were usually whitewashed and brightly painted, especially on the inside. Religious scenes filled walls, especially around altars, and bright colours and simple geometrical or floral patterns enriched architectural features such as mouldings, columns, and capitals. There were many altars, all richly furnished, and most separated from the rest of the interior by screens. A vast number of images filled **niches**, covered wall surfaces and looked down from stained glass windows. Such features complemented the rich sounds and scents that accompanied the liturgy. Reconstructing what fittings, images and paintings originally filled a given church is a major project in its own right, in which painting, stained glass and sculpture each have a stylistic history of their own.

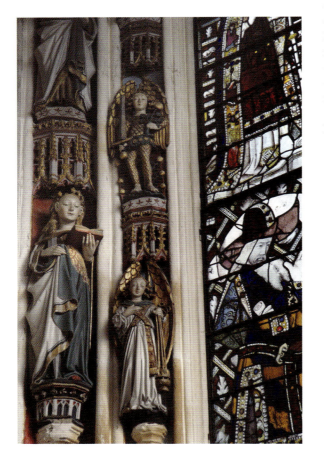

The Beauchamp Chapel (1439–62) at Warwick, though heavily restored, is one of the few places where one can experience the rich images and vivid colours that filled medieval churches.

Such features have largely disappeared, mostly as a result of iconoclasm in the 1540s and 1640s. Incidental sculpture and tomb effigies, neither of which could be interpreted as idolatrous, survive in larger numbers, if usually scraped of their colour; medieval fonts (and to a lesser extent screens) quite commonly remain in use. By contrast, a vividly coloured, life-size image of the **rood** filled the chancel arch and thus dominated the nave of every church in the land; not one has survived in its entirety. Most images in churches today are Victorian; medieval sculpture, painting, stained glass and woodwork are rare and precious.

INTRODUCTION

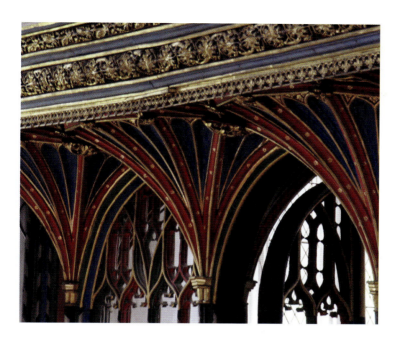

A fifteenth-century rood screen at Cullompton, Devon, in the Perpendicular style. Such screens, topped by an image of the crucified Christ with St Mary and St John, dominated the interior of a medieval church; further screens subdivided the building, demarcating areas around altars. The screen was repainted in modern times, but the colours give a general impression of the original effect.

OTHER BUILDINGS, OTHER PLACES

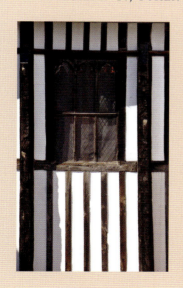

Medieval buildings of all kinds, from tithe barns to castles, shared a single ornamental vocabulary. As a result, it is possible to apply the styles in this book to many non-religious buildings. Likewise, the stylistic phases outlined in this book are also seen in Wales and, more generally, and only until the later fourteenth century, in Ireland and Scotland – and, to some extent, across western Europe. By about 1400, however, many parts of Europe were developing distinctive national styles (see page 11), and the Scots and Irish variants were far more influenced by Continental developments than by English ones.

This timber window of about 1460 at Gainsborough Old Hall, Lincolnshire, a grand secular residence, is Perpendicular in style. The surrounding timber-framing evokes the tight rectilinear patterns in which the style delighted.

ANGLO-SAXON

UP TO THE LATE ELEVENTH CENTURY

THE EARLIEST purpose-built Christian churches in Britain to survive mostly date to the sixth century, but for the next two hundred years such buildings are rare in the extreme. The earliest Anglo-Saxon work that might be encountered when exploring will usually date from the late ninth century or afterwards.

In general, this style can be seen as an offshoot of contemporary architecture on the Continent. This was itself a version of Roman and Byzantine practice, though it had developed rapidly under the emperor Charlemagne (died 814) and his successors, resulting in a style known as Carolingian. But it also reflects a rich, but almost entirely lost, tradition of elaborate wooden architecture, which included many church buildings. It seems that architectural taste was so shaped by these lost timber buildings that stone ones were admired when they imitated them in various ways.

DEVELOPMENT

The hundred years after the late tenth century appear to have seen a building boom, perhaps partly a result of the division of the country into parishes, a process that continued into the twelfth century. Walls of Anglo-Saxon date are increasingly being identified in apparently later buildings, shorn of identifiable stylistic features. Signs of Anglo-Saxon style are rarer, but usually date from the late tenth to late eleventh centuries.

DIAGNOSING ANGLO-SAXON

Though the resulting churches could be large – by about 1000 the Old Minster that preceded the current Winchester Cathedral was about 76 metres long (the current structure is about 170) – their interiors tended to comprise labyrinthine sequences of smallish interconnected spaces, very different from the large, unitary buildings that came later. One particular

Opposite:
There is dynamism in Anglo-Saxon style, with its rows of windows separated by squat balusters, its bold patterns formed of pilaster strips, and its long-and-short work running in steps up the corners of a building: eleventh-century Earls Barton, Northamptonshire.

This arch at Barnack, Cambridgeshire, has door-like proportions and blocky detailing. Typically, it is made up of irregularly sized segments of stone rather than the wedge-shaped voussoirs of the true arch.

feature, though it rarely survives, is diagnostic here: the presence of a porch-like transept known as a **porticus**, connected (usually to the nave) by a relatively narrow arch. Simple basilican buildings were not unusual, either: an example is the eighth-century monastery at Brixworth, Northamptonshire, though even here the 'arcade' is more like a series of arches punched into a solid wall than a true arcade, supported on columns. Only a few east ends survive; these usually ended in a polygonal or semicircular apse, though rectilinear examples are also known.

Almost all Anglo-Saxon arches were semicircular, and though they might be very wide, and thus in outline indistinguishable from their Norman successors, more often they are thin and narrow, more like a doorway than an arch. More usefully diagnostic are the distinctive triangular-headed arches made by laying one piece of stone against another as if they were planks of timber. Also plank-like, and diagnostic, is the arrangement of straight, unmoulded pieces of stone into simple patterns, probably derived from those on timber-framed buildings and the shallow, flat, decorative columns sometimes seen in Classical architecture. These are called **pilaster strips**. Corners are often marked by sequences of very tall, thin pieces of stone alternating with flat ones, a technique known as **long-and-short work**, easy to diagnose only when it is very emphatic. Windows are small but sometimes arranged into pairs or rows separated by stumpy columns with simple, bulgy mouldings, called **balusters** for their close resemblance to wood that has been turned on a lathe. Once one has learned to recognise them, these too are diagnostic.

A row of windows separated by balusters at Earls Barton.

Large-scale figurative sculpture and crosses covered in abstract knotted forms were both major features of Anglo-Saxon churches and can be of exceptional quality, but, in spite of this, mouldings, **capitals** and decorative sculpture in buildings often have a blocky, oddly primitive air, at once easy to recognise and hard to define.

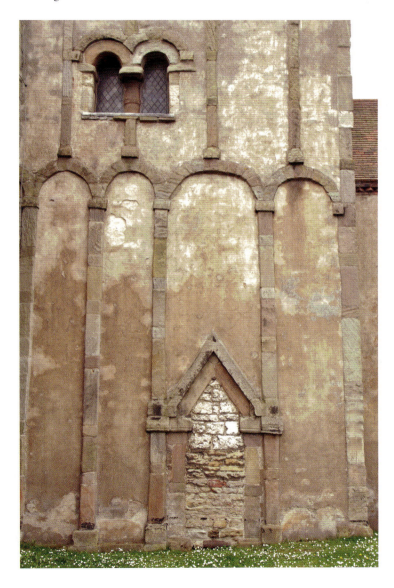

A triangular-headed arch at St Peter, Barton-upon-Humber, Lincolnshire.

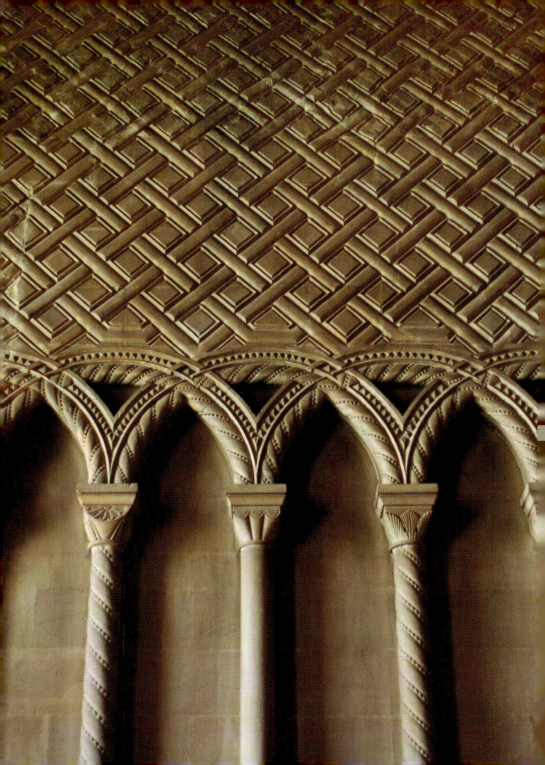

NORMAN OR ROMANESQUE

c. 1070 TO c. 1170–80

BY THE ELEVENTH CENTURY, a revolutionary architectural development was spreading across Europe. Bays were becoming elaborate, repeating multi-storey architectural compositions; the ambition and scale of stone vaulting, a Roman technique that the Anglo-Saxons had also been familiar with, was increasing. Alongside this, a new architectural vocabulary developed. The result was an architecture in which every part was clearly articulated, and in which the interiors of colossal buildings were dominated by great sequences of semicircular arches whose straightforward and emphatic detailing gave them great internal clarity and unity.

DEVELOPMENT

This innovation – more than simply a new style, it is also a new way of making buildings, especially great churches – is called Romanesque, and in England it was effectively imported in the 1060s and 1070s, around the time of the Norman Conquest, developing rapidly thereafter. In England it is often called Norman, or sometimes Anglo-Norman. Though technically this is a misnomer, for the style extends after Angevin/Plantagenet rulers had replaced Norman ones, it illustrates the fact that the large-scale introduction of the style was a result of the Conquest, and Norman Romanesque was always closely linked to its Continental equivalent. As both Anglo-Saxon and Norman architecture used semicircular arches and other motifs that were ultimately of Roman origin, both used to be seen as subdivisions of a single broader category, also known as Romanesque, though this usage is no longer current.

Romanesque is a constantly developing form of architecture, and the Norman style can be divided into two phases. The first, often encountered in great churches, runs from 1070 to *c.* 1100; during this time every cathedral (and many of the wealthier monasteries) in England was entirely

Opposite:
By the 1150s and 60s Norman design had become lively and inventive, qualities exemplified by the range of capitals on this blank arcade in the chapter house at Bristol Cathedral, and the extraordinary abstract patterning of the wall above.

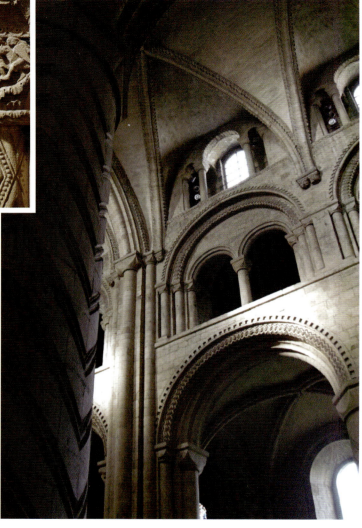

A lavishly sculpted Norman cushion capital on the doorway at Iffley, Oxfordshire. The chevron motif covering the shaft beneath, and the flat, chip-carved quality of the sculpted figures are typical of the era. The precise significance of such images is often unclear; here a mythological or knightly combat is shown on the capital.

There is an unerring logic to Norman style. At Durham, each attached shaft is topped by a cushion capital which in turn 'supports' a set of mouldings in the arch or vault above.

rebuilt, resulting in a series of grand, magnificent and often rather brutally powerful buildings whose underlying form provided a template for future developments. Some of these survive almost in their entirety (for example the cathedrals of Durham, Norwich and Peterborough).

Then, in the second phase of Norman, *c.* 1100 to *c.* 1170, architecture becomes more richly ornamental, more sophisticated and playful in detailing, and rather softer and lighter in feel. During this period the process

of parish creation was drawing to a close and lesser churches were built or rebuilt in unprecedented numbers. Most Norman architecture in such churches dates from this time. While relatively unaltered buildings are rather rare, doorways, arcades, windows and fonts of the era are very common. The identification of late-eleventh-century lesser churches is more difficult as many local masons continued to use Anglo-Saxon features, a phenomenon known as the Saxo-Norman overlap.

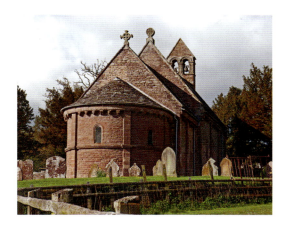

The church at Kilpeck, Herefordshire, is small, but perfectly proportioned. Its apse, shallow, flat buttresses and emphatic corbel table help mark it out as twelfth-century.

GREATER AND LESSER CHURCHES

Throughout the Norman period, east ends of greater and lesser churches alike usually ended in an apse. The presence of an apse with a semicircular plan is thus a near-diagnostic clue to a Norman date (Anglo-Saxon east ends are very rare; other forms – polygonal or square-ended – existed too but are rare and unhelpful for dating). Great churches also had many side-chapels, usually also apsidal, sprouting from the eastern wall of their transepts, or grouped in various ways around the high altar: in the handful of examples that survive, the chapels are arranged radially (an early form of **chevet**). A range of other features were seen in Norman greater churches, but many of them have since disappeared (see page 31): among those that survive are galleries (upper floors above the aisles) and large, vaulted **crypts**. Choirs in Norman great churches often extended under the crossing and into the first few bays of the nave; where this arrangement, called a liturgical choir, is preserved, usually marked by the presence of a **pulpitum** screen in the nave, it is a clue to a Norman date. Another form of plan, in which the church itself is circular, is almost always Norman, too; such churches, usually relatively small but often belonging to the category of great church in terms of elaboration, are evocations of the Anastasis of the Holy Sepulchre church in Jerusalem.

DIAGNOSING NORMAN

The number of surviving Anglo-Saxon stone vaults in the country can be counted on the fingers of one hand, so the story of surviving stone vaulting in England effectively starts in the eleventh century. The simplest kind is a **tunnel vault**, though the **groin vault** is much more common: the groin is the corner formed where two (short) tunnels intersect. Where these are made of semicircular arches, they are almost always Norman in date; where

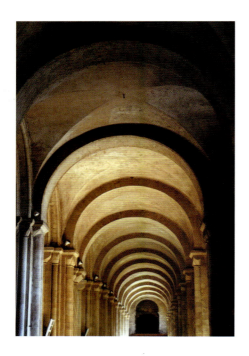

Groin vaulting, as here in Norwich (1096), is an ancient technique. The groins are the corners formed by the vault; they make an 'X' shape within each bay.

they have **cross-ribs**, they are almost always twelfth-century in date.

This is because of the major structural innovation that separates eleventh- from twelfth-century Norman: the development of the **rib vault**. The addition of ribs, following (and masking) the groins, was an old technique, usually used where vaults were perceived to be in need of strengthening, for example in a crypt; but during the late eleventh century masons began to explore its potential to help them cover vast, high spaces. At the same time they used mouldings to make ribs visually appealing as well as structurally reassuring (in fact, they do little to support the vault behind them). Sometimes a decorative motif is carved on to the surface of the ribs at the point where they cross, prefiguring the **bosses** of the Gothic era (see pages 25 and 36). Rib vaulting, at this stage simply using these X-shaped cross-ribs, spread rapidly from the late 1090s; if the vault is composed of semicircular arches, it is diagnostic; if there are occasional pointed ones one should look for other clues to date. In other respects, Norman is comparatively simple structurally, the building relying on thick walls and wide piers for its stability: the very flat **buttresses** that result are another near-diagnostic clue to a Norman date.

Almost all the earliest true arcades in English churches are Norman in date, and windows in lesser churches are rarely more than a metre or so high. Sometimes they are grouped together in pairs under a single arch, presaging developments to come; in great churches an entire façade might contain half a dozen much larger windows, arranged in levels. Any such arrangement of openings that uses semicircular arches alone is almost bound to be Norman, and twelfth-century if the windows are very long and thin; a further clue can be provided by looking at mouldings.

These are simple, but not simplistic: they play a fundamental role in giving Romanesque architecture its logic and clarity. The key to Norman mouldings is the attached shaft, a feature that at this period looks as if a narrow column with a circular section (known as a **shaft**) has been cut in half and stuck on to a flat wall: in other words, it has a mast-like form, semicircular in plan, stretching up the side of a **pier** or a wall surface, and usually distinguishable from thinner, later equivalents by its comparative

breadth and strength and the clarity it gives a composition. Stepped sequences of such shafts, each corresponding to a moulding in the arch above, form **orders** around an opening (a principle which, much diluted, remained in place thereafter). Shafts may be bunched together to make **compound piers** or reduced to the simplest possible variant, a great circular column, like an elephant's leg. This latter feature depends on simplicity and massiveness for its effect, and so should not be regarded as diagnostic until one is confident in identifying the muscular proportions of the Norman era.

It is in smaller motifs that Romanesque architecture has its clearest diagnostic features. The simplest kind of Norman capital, known as a **cushion capital**, appeared from the Rhineland in the 1070s and was used widely until the late twelfth century. Cushion capitals have four flat surfaces, each with a curved base, beneath which the capital slopes inwards and downwards in conoid segments towards the lip that separates it from the column beneath. Like many Romanesque architectural motifs, it serves to emphasise the weight of the structure above it, for it looks a little as if it has been squashed, or has developed a muscular bulge. The flat sides of these capitals began, from around 1100, to attract ornamental carving, shallow and highly stylised. Often they were subdivided, forming 'mini-cushions' known as **scallops**: sometimes two, sometimes many. These, too, are diagnostic. There is another kind of capital, called the **volute**, ultimately of Classical origin, simple at first and then seen in more creative variants during the twelfth century: when these curved, organic-looking forms lose their geometric, simplified quality and begin to be made of deeply carved foliage, one is leaving Norman (compare picture on page 24 with that on page 30).

Most other ornamental motifs are developments of *c.* 1100 and later. By far the most ubiquitous, and unmistakably diagnostic, is the zigzag or **chevron**, applied to columns running over arches, and arranged several orders deep around arches and doorways. Inventive fantasies based on the chevron, in which the zigzags jut out at an angle or perform other three-dimensional gymnastic feats, almost always date to the second half of the twelfth century. Other twelfth-century motifs can be seen as variants on

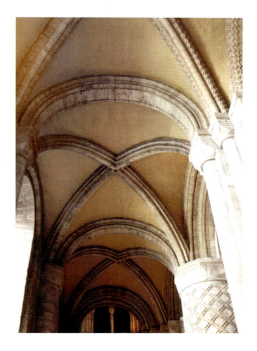

The rib vaults of Durham Cathedral (1093) are the oldest dated examples known. These thin, moulded arches masked the groins, provided structural reassurance, and did much to give Norman interiors their impressive sense of visual clarity.

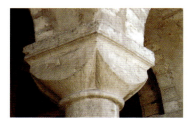

Right: A cushion capital at Winchester Cathedral (1079): four flat surfaces, each with a curved base, beneath which the capital slopes in conoid segments towards the lip that separates it from the column.

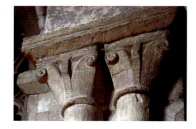

Far right: A capital divided into two or more cushions is a scallop capital; early nailhead can also be seen here, at the abbey gatehouse, Bristol Cathedral, c.1160.

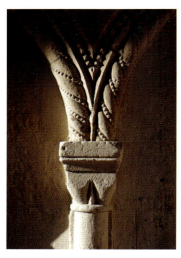

Above right: Simple, early Norman volutes on a capital at Norwich Cathedral (1096).

the chevron's abstract, jagged, energetic, geometrical quality: particularly common is the **beakhead**. Increasing numbers of other motifs were developed, and from the middle of the century their extraordinary variety and inventiveness can result in details that are unique to a single building, or possess abstruse technical names (**hyphenated chevron** is one example). The splendid entrance doorways of the era, quite often lovingly preserved in otherwise entirely Gothic buildings, are an excellent place to see these details. Often, between the arch and the lintel of the door, there is a semicircular sculpted area known as a **tympanum**, rarely seen in any other style: a tympanum combined with a semicircular arch is diagnostic.

While the specific ornamental vocabulary of Romanesque is unmistakable, the underlying ideas – from such basic concepts as bays, vaults and three-storey elevations, to many specifics (for example, shafts and their relationship to the mouldings above, and capitals as surfaces for

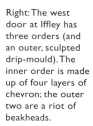

Right: The west door at Iffley has three orders (and an outer, sculpted drip-mould). The inner order is made up of four layers of chevron; the outer two are a riot of beakheads.

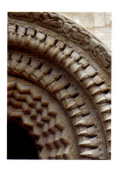

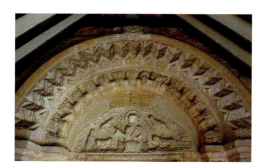

inventive carving) – would form the basic grammar from which the many different dialects of Gothic style were developed. Romanesque is thus a revolutionary turning point in the story of medieval architecture; the various transformations to come, though they were equally profound in the ways in which they changed the aesthetic qualities of a building, and contained many important technical innovations, were not fundamentally as significant.

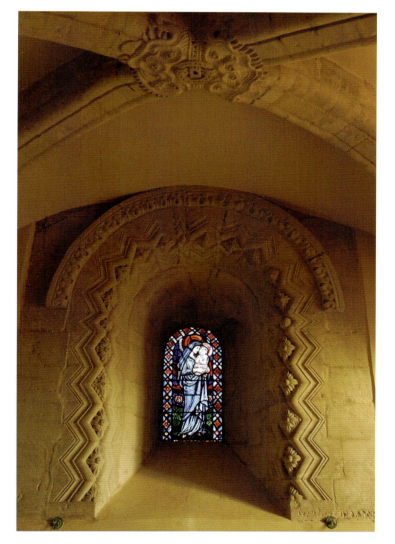

Opposite, bottom right: The sculpted tympanum at Elkstone, Gloucestershire, displays a vision of Christ in Majesty surrounded by four creatures, as described in the apocalyptic biblical book of Revelation. Each was considered an emblem of a gospel writer, and here carries an identifying tag.

The vaulted chancel at Elkstone is a memorable work of twelfth-century Norman. The point where the ribs intersect is sculpted, presaging the Gothic roof boss.

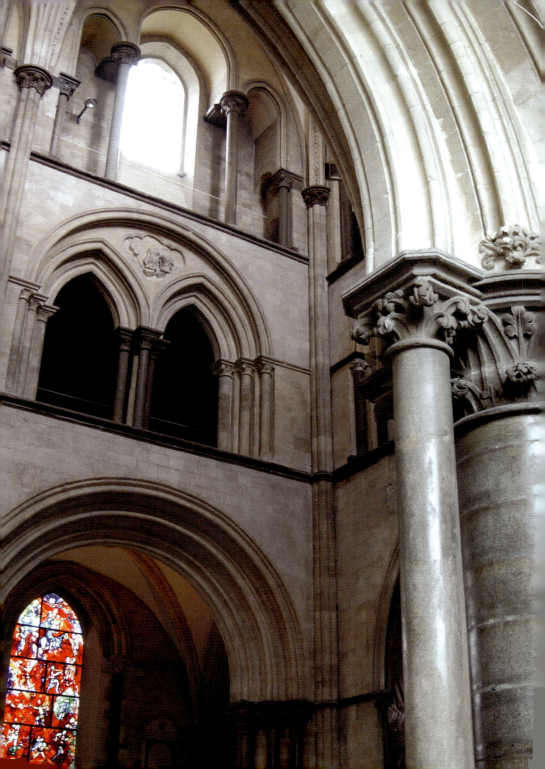

THE BIRTH OF GOTHIC: TRANSITIONAL

ALSO KNOWN AS EARLY GOTHIC, c. *1160* TO c. *1190–1200*

DEVELOPMENT

The process by which Romanesque transformed into Gothic can be seen as a kind of fifty-year exploration of the aesthetic, engineering and geometrical potentialities of the pointed arch. One of the roots of this transformation is the Norman discovery of the rib vault: as this new feature became *de rigueur*, its implications began to lead in a new direction. Romanesque was thus transformed from within, even as it reached its maturity.

As well as providing structural reassurance and looking good, ribs had solved some issues widely raised by groin vaults, masking the wobbly lines that often occurred along the groins (and which rejoice in the technical term **bastard groin**). But they gave rise to new geometrical problems of their own. Ribs run at a diagonal across a rectilinear bay. If one is restricted to semicircular arches, the diameter of the semicircle used for the ribs is inevitably larger than that of the arches on the sides of the bay, and the resulting arches rise to different heights. The vault is thus forced to bow domically upwards in the middle: hard to lay out, and awkward visually. The solution, employed even in the earliest rib vaults, was to distort the arches in various ways. They might be ovaloid or ellipses: but one solution was to break the semicircle in the middle, giving it a pointed profile by generating it from two intersecting curves of larger circles.

Pointed arches thus occur from time to time in buildings that are entirely Romanesque: indeed, they are used in the nave vault at Durham and are a frequent side effect of the interlaced **blank arcades** encountered against the walls of the more ambitious Romanesque churches (blank arcades, a luxurious invention presaged in the Anglo-Saxon period, would remain a feature of the richest churches throughout the Middle Ages; see pages 18 and 52). But some masons noted that pointed arches have qualities of their own. By varying the diameters of the intersecting circles from

Opposite:
By the time the retrochoir at Chichester Cathedral was built (after 1187), a new style of architecture was emerging. Many of the motifs that would be defining features of Early English are visible, but semicircular arches are still prominent, as are the briefly fashionable volute-dominated capitals.

MEDIEVAL CHURCH ARCHITECTURE

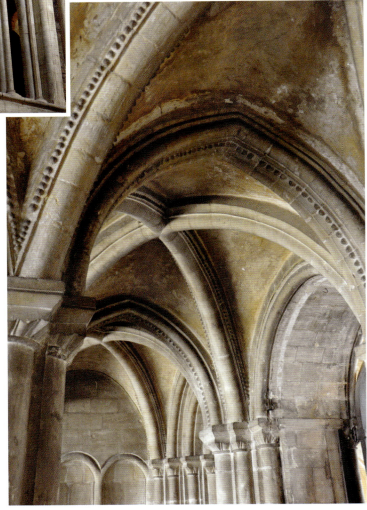

which these arches are created, and by moving the centres of these circles up or down, it is very straightforward to lay out pointed arches of different widths but the same height. Such arches may also have been thought to have unique structural properties, sending the weight of the vaults above them more directly into the corner of each bay. The buttresses and bay divisions were thus thought to be doing most of the work of supporting the vault, giving

These arches at the west end of Worcester Cathedral (probably after 1175) exemplify the shift towards a lighter, more weightless kind of architecture. They combine a prominent pointed arch with attenuated arrangements of semicircular ones, supported by capitals with deeply cut volutes and curved scallops.

A range of different arch-types have been used to vault the narrow bays of the Romanesque chapter-house vestibule at Bristol: some are semicircular, some are segments of semicircles, some are pointed, and some ovaloid in form.

designers the confidence to replace walls with hugely enlarged windows and other openings. Finally, pointed arches had unique aesthetic qualities. A building dominated by semicircular arches has a taxonomic logic to it: the eye reads each arch as separate; it sees the interior as a sequence of great arcs. Large numbers of pointed arches grouped together read as fundamentally alike: the eye perceives unity, and a tense, scintillating harmony results that was the great aesthetic discovery of the twelfth century (see pages 10 and 20).

Masons vied to explore these interrelated potentialities: indeed, a small group working in the Île-de-France as early as 1140 discovered the potential of these ideas within decades of the invention of the rib vault, as can be seen in the ambulatory at Saint-Denis Abbey in Paris. The thrust of the building was sent outwards and downwards on to skeletal arches and buttresses (soon to include arched **flying buttresses**); walls were replaced by enormous windows and arches; the pointed arch was everywhere. The feel of such buildings was profoundly different from that of anything before; people began to develop new motifs that complemented these effects. The result was a new style – Gothic.

Such ideas spread quickly across the Île-de-France, to other parts of France and across the Channel into England (though there is little left standing here before the 1170s). Experiments in England quickly took these ideas in a new direction. The English, comparatively uninterested in the effects of verticality, harmony, simplicity and light that were the dominant concerns in France, wanted, instead, to created rich, linear, patterned effects, often markedly horizontal, at least by comparison with French work. The new ability to pare walls away was used not to make them thinner but to create layers of decorative motifs. While France continued to be the touchstone of good taste throughout the thirteenth century, this was the first sign of an emphatically English approach to architecture, and the emphasis on ornament and surface pattern would remain.

DIAGNOSING TRANSITIONAL

This period of experiment is often called **Transitional** or **Early Gothic**. It is not so much a style as an evolutionary phase. Features are invented that would go on to be diagnostic for the first 'settled' Gothic style (Early English); others appear and disappear, enabling one to use them to date buildings. Just as significantly, a panoply of Romanesque motifs, such as the cushion capital and its variants, never seen after the 1180s–90s, or, a little later, the chevron and the semicircular arch itself, were consigned to architectural oblivion, anathema to the new aesthetic. The Transitional 'style' is exploratory, experimental: designers had no idea that the colossal window and the pointed arch would dominate design for well over three

hundred years, developing in a series of stylistic phases, each a subdivision of Gothic.

The presence of a pointed arch in a building otherwise dominated by semicircular ones is not enough to call a building Transitional, though it is a clue. There need to be some additional signs of stylistic change. But, as a rule of thumb, the more prominent the pointed arches are, and the more other motifs are present that would go on to be seen in Early English, the later the date; indeed, many prefer to call those designs of the 1170s–90s that are plainly Gothic in spirit, but have yet to settle into a defined style, Early Gothic rather than Transitional. Semicircular arches have become rare by the 1190s, and are only occasionally seen from then until about 1220, after which they disappear completely; in any case, by this time everything else, from mouldings to foliage, has profoundly changed.

One diagnostic motif for *c.*1170–90 is a distinctive form of volute capital, much more delicately carved than its Romanesque predecessor and often apparently modelled on Roman capitals of the Corinthian order. This is a French invention, and a symptom of a wider search for motifs that emphasise weightlessness. Volutes are organic-looking, plant-like features, incapable of supporting anything very heavy, let alone a stone arch; the contrast with the cushion capital could not be greater. This is even truer of the **waterleaf capital**, with its smooth-sided leaves and tiny volutes. Mostly confined to the north and the eastern seaboard of England, it is the single most straightforwardly Transitional diagnostic motif. Many capitals of the era sit somewhere between the volute and waterleaf. Scallops, especially in the West Country, sometimes take on a curved form known as a **trumpet**

Right: With its big, broad leaves and tiny volutes, often curling upwards, the brief flowering of the waterleaf capital, seen here at St Mary, Barton-upon-Humber, Lincolnshire, epitomises the weightless effects sought by architects as Gothic emerged.

Far right: These curving trumpet scallops at Ogbourne St George, Wiltshire, turn into plant motifs, in turn revealing the Romanesque roots of stiff leaf.

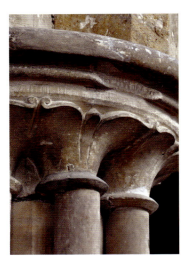
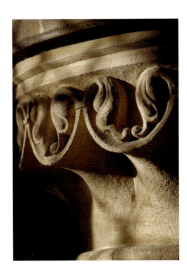

scallop. Meanwhile, while the chevron and its variants continued to be used in the first decades of the thirteenth century (they are gone by about 1220), in the later thirteenth century new motifs, again making such forms lighter and more delicately linear in effect, were developed: of these **nailhead** (see page 34) would become diagnostic for Early English, taking the graphic energy of chevron but making it lighter, more dynamic in quality. Nailhead then, in contexts where most other features are Romanesque, is a marker of a Transitional date. French **sexpartite vaults**, in which bays are grouped in pairs, are also seen in a few exceptionally cosmopolitan English buildings, and are diagnostic for Transitional and the first decade or so of Early English.

GREATER AND LESSER CHURCHES

A further change took place in the course of the twelfth century. It is at this time that the architectural attributes of the great church (see pages 9–12) were settled, developing only subtly thereafter. Between 1100 and 1200, rib vaults had become *de rigueur* for great churches; large, vaulted crypts became, and remained, rare; and the upper-level gallery was abandoned and replaced by the **triforium**. This is merely an attic above the aisle vault: it can result in an elevation in which the middle storey is little more than a row of blank arches – though it can also be massive, with a presence in the elevation akin to that of a gallery (a feature sometimes called a false gallery). The triforium is rare in Romanesque buildings, and the gallery is almost unknown in Gothic ones. Various other defining features of the Romanesque great church (such as the elaborate western complexes known as 'westworks' and the multi-towered effects achieved by placing small towers on the corners of aisles and transepts) also disappeared: so few examples of these survive in England that they are not described above. As a result of all this, worship took place on a single storey, and the focus on the east end was even more emphatic; more to the point, the resulting consensus as to which features define the great church would remain in place until the end of the Gothic era in the sixteenth century.

Ensuing changes to this great-church template are few (see pages 75–76), but, as a very rough rule of thumb, triforiums tend to decrease in prominence, and a number of experiments with polygonal plans are seen in the Decorated period, as a result of which apses with polygonal rather than curved ends, not impossible at any Gothic era, make a small-scale comeback.

This latter feature reflects a development that affected churches of all kinds, not only great churches. This was a desire for longer east ends with flat eastern walls, increasing the space around the altar and turning the east wall into an enormous ornamental arrangement of windows. Thousands of east ends were rebuilt from the late twelfth century onwards, and almost all

A gallery (right, at Gloucester, 1089) is an upper floor to the aisle, large enough to contain windows and chapels; this example is vaulted. By contrast, a triforium (below, at Salisbury, 1220) is nothing more than an attic space.

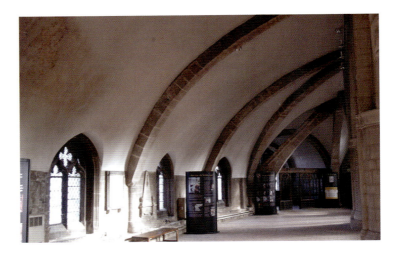

replaced an apse with a longer structure with a rectilinear plan. These east ends also began to hold small stone-built fittings, most commonly the **piscina** (in which the priest washes his hands before performing Mass; sometimes seen in the twelfth century), **sedilia** (seats for the officiants at the Mass), and sometimes an **Easter sepulchre** (which symbolised the

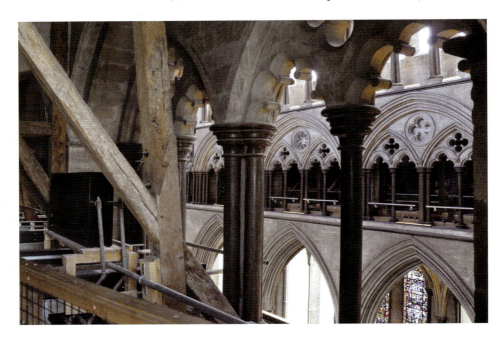

THE BIRTH OF GOTHIC: TRANSITIONAL

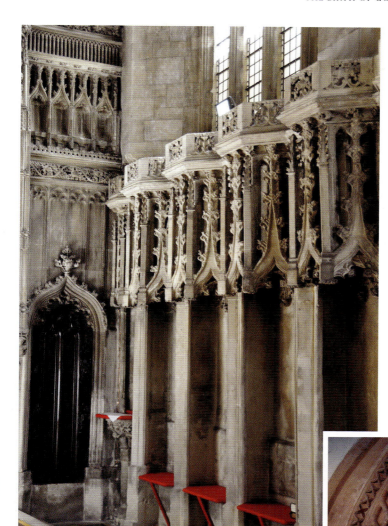

From the thirteenth century to the Reformation, a piscina (seen, here, between the door to the left and the sedilia to the right) usually stood on the south side of an altar; important altars also had sedilia, usually with three seats, designed in whichever architectural style was prevalent at the time. This Perpendicular example is in the Lord Mayor's Chapel at Bristol.

This door at St Mary, Ely, Cambridgeshire, is a work of an exploratory era, in which new motifs, old motifs and motifs never to be repeated sat side by side in a single composition.

tomb of Christ during Easter rituals). Great-church east ends acquired complex rectilinear plans, often with a Lady Chapel extending behind the high altar. All these developments increased the emphasis on the high altar; it is surely no coincidence that the doctrine of the Transubstantiation, in which the consecrated Host is held to be miraculously transformed during Mass, was being promulgated at this time.

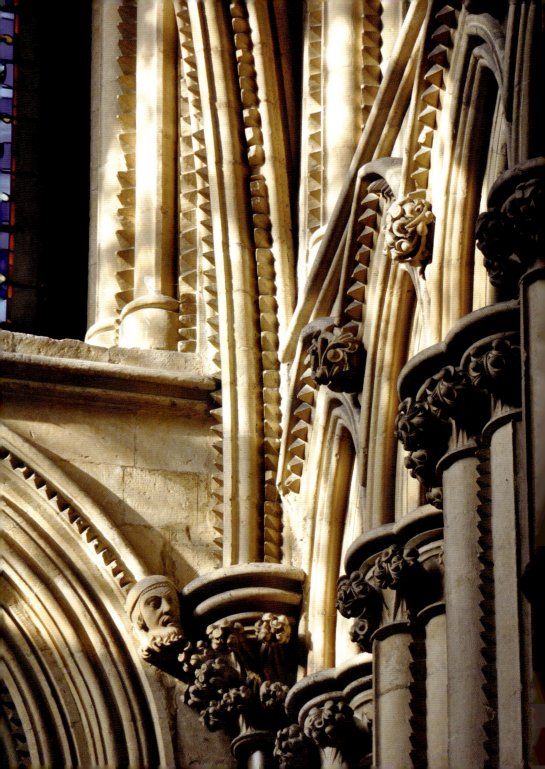

GOTHIC I: EARLY ENGLISH

c. 1190–1200 to c. 1260

Towards the end of the twelfth century a consensus developed about style. The range of motifs architects drew on suddenly narrowed, resulting in a clear, consistent architectural language. The result is the first mature Gothic style – Early English. It is elegant, composed, often nobly impressive, sometimes austere, and very easy to recognise.

DEVELOPMENT

This clear set of architectural rules has been established by 1190; it takes a decade or so more to settle down, then subsequently barely changes until the 1230s and 40s, when it develops a marked late phase. Most of its diagnostic features remained standard until the 1260s.

Two inventions of this late phase would colour the rest of the story of Gothic architecture. These are a new kind of vault, the **tierceron** vault (see page 49), and the decorative technique known as window **tracery**. These inventions, and the gradually more lavish ornament that went with them, are seen by some as marking the inception of the next style, Decorated, but are here treated as a late phase of Early English. The change from Early English to Decorated is gradual, but only in the 1260s does the ornamental grammar of Early English truly begin to loosen and transform.

DIAGNOSING EARLY ENGLISH

Early English arches are, of course, pointed, though semicircular arches sometimes appear incidentally until about 1220. The pointed arch then remains almost universal until the early sixteenth century. The easiest type of pointed arch to create is **equilateral** (see page 82): that is, it is as wide as it is high. Sometimes the arch is wider than it is high, in which case it is **depressed**. Equilateral arches are the commonest type of Gothic arch, and neither they nor their slightly depressed variant are on their own useful for

Opposite:
Lavish use of nailhead – a series of small, sharp pyramids, often running up the side of an arch or a column – at Lincoln Cathedral (after 1237–9).

MEDIEVAL CHURCH ARCHITECTURE

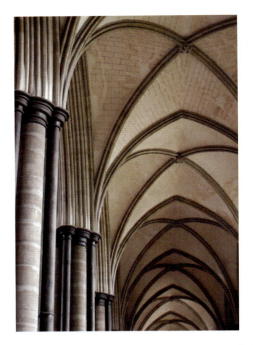
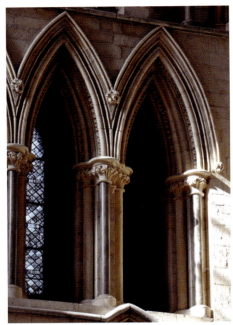

Above: The slim, finely moulded ribs and bosses of stiff-leaf foliage mark this out as a simple but elegant Early English cross-vault: Salisbury Cathedral, 1220.

Above right: The attenuated form of the lancet arch: Lincoln Cathedral, early thirteenth century.

dating, except that they help mark a building out as Gothic (or Transitional) rather than Romanesque. However, the **lancet arch**, thin and vertical in emphasis, is a reasonable, if not foolproof, clue that a building might be of Early English date (see page 82). While never very widely used, lancets are most commonly seen between the later twelfth and the mid- to late-thirteenth century. Doorways in some buildings have a shouldered profile – two arcs, two short vertical elements and a lintel: this is rare, but diagnostic.

Vaults were now composed almost entirely of pointed arches, and designers made their ribs thinner and thinner, with complex mouldings (see page 42) and – a new feature – emphatic and richly carved bosses where the ribs intersected. However, the basic underlying form of the vault was unchanged: two ribs, following the groins, making an 'X' shape. These simple cross-vaults, vaults using cross-ribs, continued in use for many centuries, so one needs to be able to diagnose the moulding of their ribs or the foliage on their bosses to be able to date them: like the equilateral arch, they merely tell us that a building is Gothic rather than Romanesque, though a building that uses them exclusively is likely to be Early English. **Ridge ribs** (see pages 10, 50 and 66) are an additional feature, unique to England and unknown in Romanesque buildings, and one of the causes of the horizontal emphasis so marked in English buildings when compared to their French contemporaries.

It is with Early English that windows become centrepieces of architectural design: most are long, thin, narrow openings with pointed arches at the top. Because of their verticality, these are called **lancet windows**, even when the arch in the window-head is equilateral. Small Gothic single-**light** windows are possible at any date from now on, but Early English lancet windows have no extra detailing to interrupt the cleanness of their outline (see page 81). Large ones – a height of 6 metres is not unusual, and the Five Sisters at York Minster are no less than 16.3 metres high – are standard from the end of the twelfth century through to the mid-thirteenth century, and diagnostic. They are especially easy to recognise when grouped together to form elegant, simple and rather grand patterns: most commonly arranged in pairs or as **stepped lancets** of three or more windows. When one is sure of the difference between these and any kind of tracery, such arrangements of lancet windows are among the clearest and most diagnostic motifs in all window design. They may be separated by arches with complex mouldings, supported by little capitals and columns, elegant **rere-arches** that encourage one to read the windows as a single composition. This idea is possible at any period, but the effect is particularly memorable when it frames a noble group of stepped lancets.

Tracery was invented at Reims in about 1210, but dated examples in England are not known before the 1240s. However, an evolutionary stage leading towards tracery is often seen in the preceding decades. Once placed in groups, windows might be further united by putting a blank arch over them. The wall space between the windows and the arch might then have further openings punched in it, often small circles. This very specific phenomenon has a separate name of its own: **plate tracery**. This (though

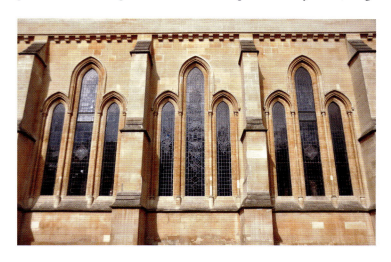

Stepped lancet windows at Temple Church, London (complete by 1240).

MEDIEVAL CHURCH ARCHITECTURE

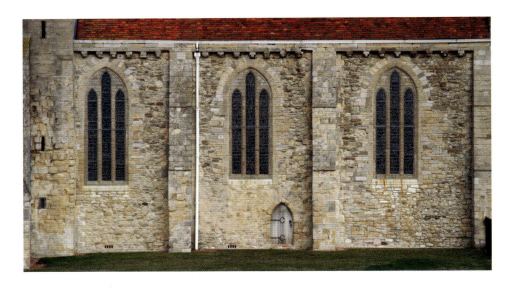

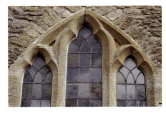

Stepped lancets become plate tracery at Portsmouth Garrison Church, before 1214; comparable patterns in later styles (Decorated, right, at Bampton, Oxfordshire; late Perpendicular, lower right, at West Walton, Norfolk) are not stepped lancets: they are tracery within an arch rather than separate windows placed close together. These windows also have cusps, and the Perpendicular example uses four-centred arches.

single and grouped or stepped lancets remained far more common, is diagnostic for these decades. The next step was to remove these stretches of wall altogether, so that the outer arch, previously blank, now becomes the edge of the window itself, with the two-lights-and-a-circle motif within it now formed of thin, rib-like, moulded pieces of stone known as **bars** (see pages 40–41). This delicate-looking pattern is the earliest type of window tracery. Tracery fills the window-head, that is, the arch at the top of the window; the space below is divided into parallel lights separated by vertical mullions. Curved **cusps**, also called foils, enrich the patterns further, most typically placed in the arched top of each light or the circlet above. The result, three-lobed **trefoils**, four-lobed **quatrefoils**, five-lobed **cinquefoils**, etc, would remain part of the decorative vocabulary of Gothic

38

GOTHIC I: EARLY ENGLISH

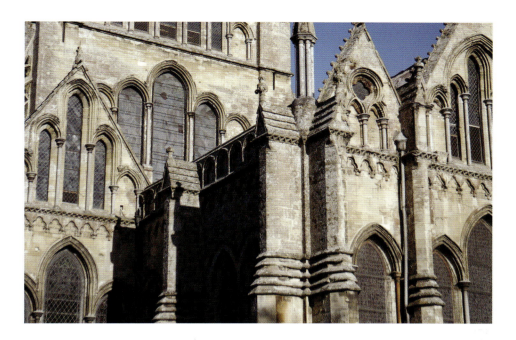

Above: Noble arrangements of Early English lancet windows – stepped, paired, placed in or adjacent to blank arches – at Salisbury Cathedral (1220). Simple crockets, an invention of the period, run up the gables.

from now on. To distinguish plate from bar tracery, ask oneself whether what one is looking at is a series of windows grouped under a single arch, or an arrangement of thin ribs, forming a pattern within a single window.

Bars could in theory be used to form an infinite variety of patterns. But at this point the patterns used are very limited, reflecting the rule-bound nature of Early English taste. Most typically, two-light windows have a circlet, usually cusped but sometimes uncusped, above the lights; four-light windows are created out of a pair of two-light windows, separated by tracery **sub-arches**, with a larger foiled circlet placed above them; plate tracery

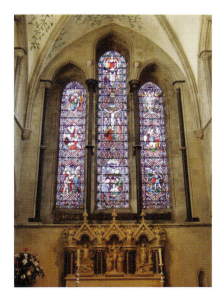

Left: These stepped lancet windows in the east wall of Boxgrove Priory, West Sussex (c. 1220), are framed by graceful rere-arches with slim Purbeck-marble shafts, stiff-leaf and bell capitals, and dogtooth decoration.

39

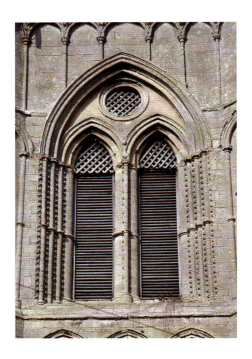 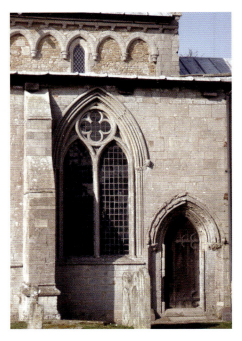

Above: A typical plate tracery pattern: paired lancets, with a circlet above them, under a single arch.

Above right: The same arrangement becomes bar tracery, with a quatrefoil in the circlet. Both are at West Walton, Norfolk: either a designer of the 1240s chose to use the older technique for his belfry windows, or the first window is a little earlier than the second.

versions of stepped lancets are also seen. Three-light windows contain a pyramid of three foiled circles. Strictly speaking, this and all subsequent window tracery patterns can be called bar tracery, but the term is rarely used for windows that do not have this canonical pattern, which is diagnostic for the 1240s to 1260s (during which time plate tracery and giant compositions of lancet windows die out quite quickly): after that, patterns develop in ever-increasing variety, and we usually talk simply of 'tracery'. The simple, geometrical arrangement of early bar tracery forms a template for these later developments: for example, no matter how complex the resulting pattern, sub-arches are crucial to the underlying structure of most four-light tracery patterns (see pages 41, 54, 56 and 70). Indeed, both these early patterns and the variations on them that were coined between the 1270s and *c.* 1300 are all often called Geometrical tracery. But for now, although a major development has occurred – enormously high and wide windows can be made, and filled with beguiling stone patterns – the range of designs used remains limited.

In general, Early English columns are slimmer and thus appear less strong than anything that went before, enhancing the comparatively weightless effect sought by Gothic buildings in general; in lesser churches they may simply be of a relatively thin, drum-like form, a more elegant

GOTHIC I: EARLY ENGLISH

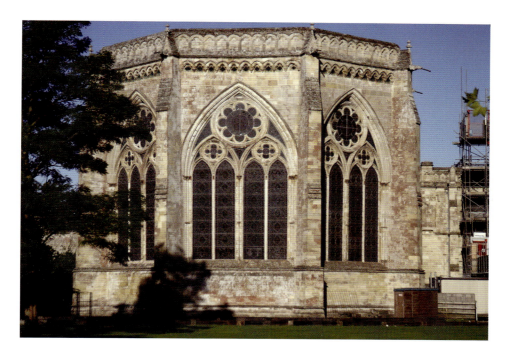

Four-light bar tracery, a tessellation of the two-light pattern, on the chapter house at Salisbury Cathedral (before 1263). The resulting pattern contains two sub-arches.

version of the Romanesque 'elephant leg'. An important and more diagnostic development affected many compound piers and small-scale features such as blank arcades. The half-shafts or attached shafts that bulged outwards from the surface of Romanesque columns became completely circular, detached from the pier itself, and extraordinarily thin, resulting in features known as **en-delit shafts**: often four of these surround a larger central column. One can normally just about slip one's fingers between the shaft and the column or wall behind it.

This shafting is one of the diagnostic features of the style. Very often, the stone it is made from has a dark, glossy sheen that contrasts with the stonework around it. This effect was usually achieved by polishing a limestone until it changed in tone. The stones found on the Isle of Purbeck in Dorset responded particularly well to this treatment, and the resulting effect is often generically, if not always correctly, called Purbeck marble. Often, too, clasping **shaft-rings** interrupt the pronounced verticality of these shafts. Polished shafting had Romanesque origins, but its use to make slim shafts on a lavish scale was pioneered at important Transitional buildings such as the east end built at Canterbury Cathedral from 1174. Designers everywhere then appear to have fallen in love with this idea, and buildings can appear to be draped in these glossy, pipe-like shafts, nestling

The deep scoops and fillets typical of thirteenth-century mouldings.

Four *en-delit* shafts around a column, capped by bell capitals, at Salisbury Cathedral. The columns and the capitals are of Purbeck marble, but polished to a warm grey and a glossy black respectively, making for a delicious contrast with the bone-white limestone of the arch, with its complex, deep-cut mouldings. Stonework such as this would have been left unpainted.

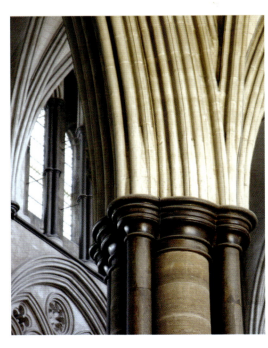

amongst the mouldings that separate lancet windows, or covering a façade in what can look like delicate stone scaffolding; the effect is diagnostic for *c.* 1190 to *c.* 1260.

These columns and shafts support capitals that are often simply moulded, but such **bell capitals** remain little changed in the first phase of Decorated. However, capitals are the best place to see the Early English diagnostic feature *par excellence*. This is the fantasy foliage we call **stiff leaf**. Its origins lie in the experiments of the mid- to late twelfth century: waterleaf and volute capitals often have early versions of stiff leaf on them (see page 26). By the 1190s all other kinds of foliage have withered and died, and there is then simply no other way of rendering plants until the 1260s.

Stiff leaf is easy to recognise. The plant is supported on a long, tendril-like swaying stalk; each ends in a three-lobed leaf. The central lobe, almost a separate leaf, is larger than the others, and the outer two curve away from it, rather like a fleur-de-lis. The lobes often have marked ridges, and the

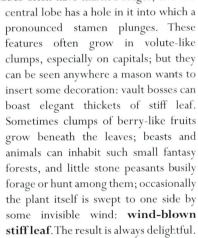

central lobe has a hole in it into which a pronounced stamen plunges. These features often grow in volute-like clumps, especially on capitals; but they can be seen anywhere a mason wants to insert some decoration: vault bosses can boast elegant thickets of stiff leaf. Sometimes clumps of berry-like fruits grow beneath the leaves; beasts and animals can inhabit such small fantasy forests, and little stone peasants busily forage or hunt among them; occasionally the plant itself is swept to one side by some invisible wind: **wind-blown stiff leaf**. The result is always delightful.

Among other ornamental motifs, chevron gets rarer and rarer from the late twelfth century and into the thirteenth. It is gradually replaced by **nailhead** – rows of tiny sharp pyramids – and its elaborate variant, **dogtooth**, an invention of Early English in which

An *en-delit* shaft of polished Purbeck marble, clasped with a shaft-ring to mask joins in the stonework, at Boxgrove Priory.

the sides of the pyramids are cut away to leave a stiff, petal-like pyramidal form. Indeed, by 1200, most of the huge range of other motifs that existed from the 1150s to the 1180s had vanished: this narrowing of the range of decorative carvings to stiff leaf, dogtooth and nailhead is one of the most remarkable expressions of the canonical, rule-bound nature of the Early English style. The mouldings in which nailhead and dogtooth sit are deep and complex, with great scoops and tight bulges, sometimes marked by raised, crease-like elements known as fillets (see page 42). Column **bases**, the thickened feature that acts like a 'foot' to the column as a whole, often have distinctive **waterholding mouldings**, a curved, gutter-like dip that remained in use throughout the thirteenth century. Such deep forms result

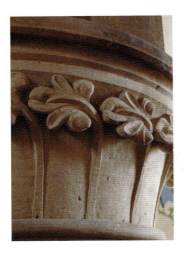 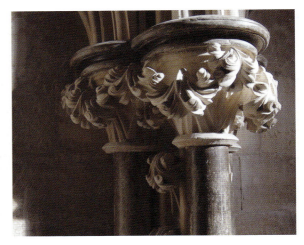

Above: Individual sprigs of stiff-leaf foliage, here with bulbous leaves either side of the three main ones, ring a capital at Ogbourne St George, Wiltshire.

Above right: Clumps of stiff leaf in the Angel Choir of Lincoln Cathedral (from 1256).

in strong effects of light and shade and play a key role in making Early English a style with a markedly linear quality.

All these motifs are used on a feature that was new to architecture, and that would be highly influential in the future. This is the creation of built-in stone fittings – sedilia and piscinas, joined by canopied tombs from the 1250s – which were designed like miniature buildings, with arches, canopies and gables raised on columns and capitals. The same thinking is also seen in the complexity and delicacy of such features as blank arcades and rere-arches, both, in their mature form, ultimately Romanesque inventions; niches, too, now appear in large numbers for the first time. These are little tabernacles in which statues could stand, ranked up buttresses or lined up across façades. **Crockets** appear (see page 39): spiky, vegetal forms running up the side of a gable. In the Early English period these are shaped like a small tongue or a thick sprig of stiff leaf; they rise to finials. At this stage they are comparatively rare.

The Early English style is defined by a series of underlying principles: it is a simple, consistent, highly rule-bound aesthetic that favours effects of linearity and weightlessness over all other things, while continuing the principle, evident in Romanesque, that architectural design should ultimately articulate and clarify the underlying form of a building. Everything invented in the Transitional era pulls towards these principles; everything rejected at that time pulls against them. As a description of Lincoln Cathedral written in the 1220s puts it, Early English buildings are 'strong, precious and gleaming, … soaring and lofty, their finish clear and resplendent, their order graceful and geometrical, their beauty fit and serviceable'. The resulting hegemony of style lasted half a century or more.

GOTHIC I: EARLY ENGLISH

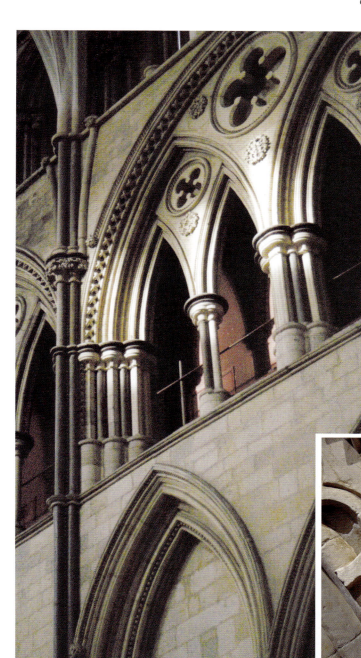

Deeply cut linear mouldings, dogtooth motifs running up the arch, plate tracery-like arrangements of lancet-headed openings and cusped circlets, bell capitals and shafts of polished stone, and stiff-leaf foliage. The distinctive language of Early English in the triforium of the south transept at York Minster (from c. 1225).

Dogtooth, in which the sides of the little pyramids that form nailhead are carved away, leaving the corners as straight-sided, leaf-like motifs: Compton, Surrey.

45

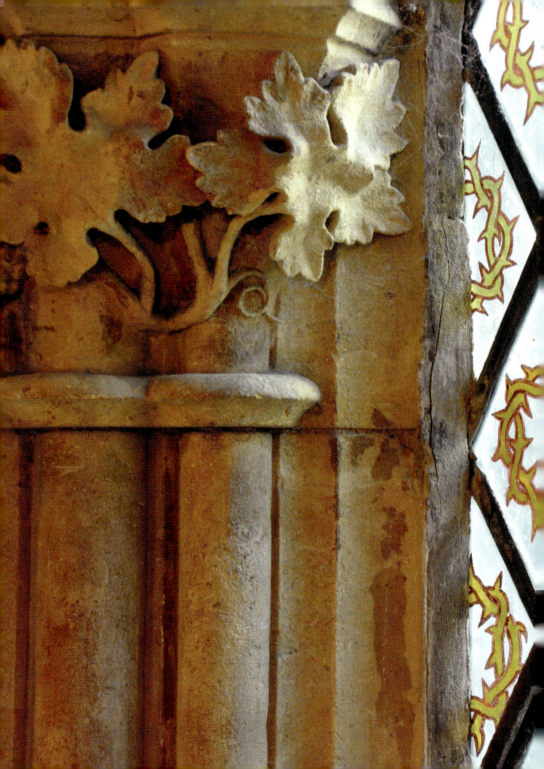

GOTHIC II: DECORATED

GEOMETRICAL, c. 1260 to c. 1300–20; CURVILINEAR, c. 1300–20 to c. 1350–60

THE TIERCERON VAULT and bar tracery were inventions with considerable ornamental potential. It is in the 1260s and 1270s that a wide range of motifs, from the carving of foliage to the patterns made by tracery, began to change as designers explored further new decorative effects. The result was a gradual breakdown of the Early English consensus, and the birth of a new and varied style, Decorated. But Decorated is really a century-long process of experiment, and it can be subdivided into two phases, Geometrical and Curvilinear, that are almost separate styles in themselves. Everything in this long period, however, can be understood as a manifestation of a single 'Decorated Idea'.

The Decorated Idea aims to blur distinctions: between wall and window, building and fitting, architecture and decoration. This is the great age of the customised fitting, with tombs, sedilia and other features treated as one-off pieces of architectural design, works of sculpture that were also fantasy buildings: **micro-architecture**. Such fittings become elaborate compositions of openwork spirelets and pinnacles, sporting tiny, sculpted niches, buttresses and vaults, sprinkled with energetic crockets and finials. The effect can be as if the building was transmuting into a plant, or as if forms easier to achieve in elaborate metalwork were being rendered in stone. Tiny grotesque beasts abound in the carving: this is the age when gargoyles are at their most prominent, enhancing the spiky silhouette of a building. The finest results are among the most arrestingly complex and beautiful creations of any era. Micro-architecture illustrates the underlying aim of Decorated style: to create buildings that are overwhelming environments, marshalling a wide range of craft techniques – stained glass, tilework, painted decoration – to create a powerful all-encompassing effect. Inventiveness, playfulness and variety are the themes; the architectural clarity of the past is subverted and undermined,

Opposite: Naturalistic foliage, almost seeming to photosynthesise the light of the adjacent window, in the cloister at Lincoln Cathedral (c. 1290).

Right: The sedilia at Exeter Cathedral (from 1316–17) were designed by the master mason Thomas of Witney, one of the greatest creators of complex micro-architecture.

Below: The sedilia at Dorchester Abbey, Oxfordshire (probably 1330s), feature an explosion of ornamental ideas: small sculpted arches with complex cusping; sculpted buttresses, gables and tracery motifs; glimpses of capriciously shaped windows, each filled with densely coloured stained glass. Crockets, grotesque heads and ballflower motifs add to the rich effect.

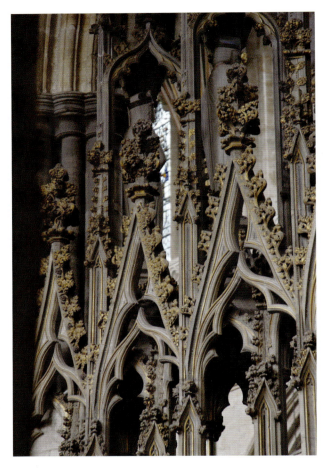

clouding one's sense of the underlying form of the building. Windows are sometimes rendered on flat surfaces in low relief, prefiguring Perpendicular **panelling**. But Decorated can speak in many voices; its designers can move from the plain to the elaborate, the conventional to the experimental, in a single building, deliberately giving different voices or qualities to different parts; indeed, a surprising number of Decorated parish churches are rather plain, as if in deliberate contrast to the exuberance seen elsewhere.

DEVELOPMENT

The Decorated Idea is first fully expressed in such French buildings as the Sainte Chapelle on the Île de la Cité, Paris (c. 1240). Such structures inspired a series of exceptionally ornate late Early English buildings, in particular

Westminster Abbey (*c*. 1245), before the formal details of architectural style began to transform (see page 35), and the first of the two phases of Decorated, which ran from the 1260s to around 1300, truly began. During this Geometrical phase the Decorated Idea transforms architecture in a rather gradual way – as if Early English is gradually loosening its tight canon of stylistic rules. Hence the disagreements over where to place the dividing line between it and Decorated. In the second, Curvilinear phase, a series of innovations stimulate a change of direction and a more self-conscious process of experiment. The roots of this phase lie in a small group of buildings, of which the most influential, the Eleanor Crosses and St Stephen's Chapel in the Palace of Westminster, were funded by the Crown and begun in the 1290s. Such works would be sources of inspiration for some time, but the two most immediately influential new ideas were a kind of arch, the **ogee**, and a type of vault rib, the **lierne**. These motifs and their implications begin to pervade architecture in the 1310s and 20s; the resulting Curvilinear Decorated is then dominant until the mid-fourteenth century and hangs on in some areas, especially along the eastern seaboard and in the north, well into the late fourteenth century.

At its height in the 1320s and 30s, Curvilinear Decorated is the backdrop to a series of highly exploratory experiments – almost an *avant-garde*. This period of rapid evolution gave birth to the final medieval style, Perpendicular. The greatest of these works, such as the Octagon at Ely and the east ends at the cathedrals of Wells and Bristol, are works of genius which almost defy stylistic categorisation. Such designs appear to have had a substantial influence on European architecture: while the extent of this is much debated, it is agreed that ideas invented in the English West Country at this period can be found as far away as Prague.

DIAGNOSING DECORATED

Let us start the story of Decorated with the tierceron vault. In the nave of Lincoln Cathedral, from the 1220s (see page 10), additional ribs were inserted between the cross-ribs that followed the edges of the groins and the ridges of the vault. Each of these **tierceron ribs** runs from the springing of the vault to its ridge, just like the cross-ribs of a groin vault, but these ribs do not follow the groins. The resulting increase in the number of ribs gave vaults a spreading, organic quality and reduced the viewer's sense of its underlying structural form. These vaults had their ultimate roots in the one-off 'crazy vaults of Lincoln' built in the east end of the same church from 1192 (this was also the place where the ridge rib was invented). Tierceron ribs become widely popular only in the 1260s and 70s, but their luscious effect was explored widely thereafter, with such memorable results as the 96-metre-long run of vaults at Exeter Cathedral (1280s onwards) and

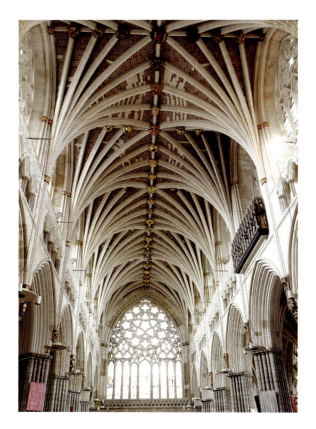

The tierceron vaults at Exeter Cathedral, probably designed in the 1280s, feature eleven separate ribs, each curving like a palm-tree from the springing point of the vault to its ridge rib. They grace what is often said to be the longest unbroken run of Gothic vaulting in the world.

the vault that spreads over the octagonal chapter house at Wells Cathedral (after 1286). However, the tierceron vault on its own is not diagnostic as, while its use as the centrepiece of a design decreased significantly during the fourteenth century, it was never forgotten, even as further new types of vault were developed.

The idea of the tierceron vault had important implications. Ribs no longer had to reflect a vault's underlying structural form by following its ridges and groins. They could thus be used purely for their decorative effect. The next step was to add further, shorter ribs, in the simple pursuit of pattern for pattern's sake: liernes. A handful of designers in the 1290s (and perhaps a little before) tried this, and in the early fourteenth century liernes began to spread, increasing in complexity of pattern as they did so. Liernes are distinguishable from tiercerons because they link one rib to another, rather than running from the base to the apex of the vault. They can be used to cover curved ceilings with a potentially infinite variety of stone patterns. Lierne vaults, like tierceron vaults, never died; indeed, they remained the default vault-type through to the Reformation (see page 66), and the presence of a lierne vault alone (their development is a complex study in its own right) can be used diagnostically only to indicate that a building dates to after *c.* 1300, that is, to identify it as Curvilinear Decorated or Perpendicular in style. They sometimes have cusps added to them, rather like tracery; these are usually large and emphatic in Curvilinear Decorated buildings, when the tendency is to use the liernes to form big, dynamic diamond shapes and net-like patterns.

This pattern of development is comparable to that of arches. In the Geometrical phase of Decorated, the lancet arch becomes much less common, leaving the equilateral arch (and sometimes depressed variants of it) as the default arch-form, as it remains throughout the medieval

GOTHIC II: DECORATED

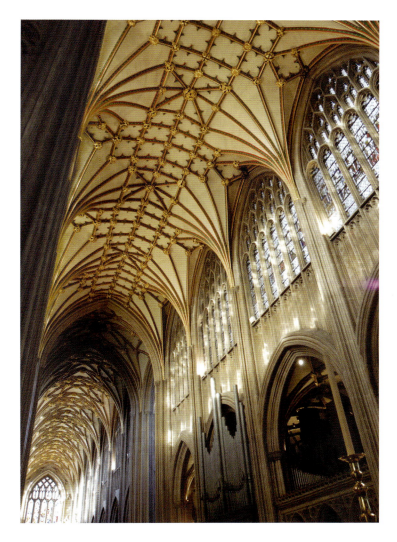

The tiercerons and cross-ribs of the vault at St Mary Redcliffe, Bristol, are surrounded, and in some cases interrupted, by shorter lierne ribs, forming cusped patterns of diamonds, triangles and squares. Though the windows are Perpendicular, this fourteenth-century design is characteristic of Decorated lierne vaults.

period. However, the sinuous double-'S' curve of the ogee (see pages 52, 82) embodies much about the Decorated Idea: it is counter-intuitive (one can never imagine an ogee arch holding anything up effectively), and more obviously found in plants and metalwork than in buildings of stone; it thus prioritises decorative effect over structural clarity. Like the **lierne vault**, the ogee appears in the 1290s, though, unlike the lierne, it is by no means an English invention; the earliest examples are found in third/second-century BC India.

Ogee arches, lavishly sculpted, on the blank arcades at Beverley Minster, East Yorkshire (c. 1335–40).

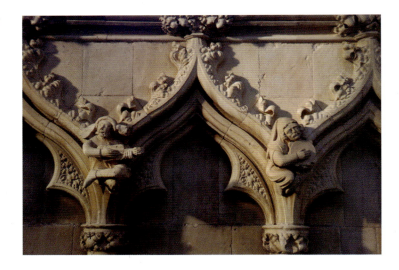

Opposite: Positioned beneath steep, crocketed gables, these nodding ogees on the outer north porch at St Mary Redcliffe, Bristol (probably c. 1320), give the surface of the structure a swaying, rippling, organic quality; large, brightly painted statues once stood beneath each such arch.

In the first decades of the fourteenth century the ogee starts to transform architectural style, as masons explore the ways in which ogival curves can be applied to patterns, especially window tracery, and micro-architecture. In some particularly lavish buildings, of which the Lady Chapel at Ely Cathedral (from 1321) is the most famous, blank ogee arches and ogee-headed niches are draped over entire wall surfaces; many bend outwards into the space, forming **nodding ogees**. Even today, stripped of its colour, the effect is like inhabiting a metalwork shrine, or standing inside a hothouse filled with various kinds of architectural plant life. Though in the later fourteenth century the ogee arch loses its defining role in architectural style, it is never forgotten, playing a relatively minor but quite common role in Perpendicular designs. On its own it is thus not straightforwardly diagnostic: like the lierne vault, it simply denotes a date after 1300.

The question to ask, then, when faced with ogee curves, is whether they define the composition as a whole: the more a design is imbued with these flickering, organic curves, the more confidently one can ascribe it to the Curvilinear era. Window tracery is perhaps the best place to see this.

In the Geometrical phase, the canonical patterns of early bar tracery (see pages 40–41) breaks down and designers begin to explore a vast range of other patterns. All, at this stage, can simply be generated by playing with a compass, creating intersecting curves, or taking regular shapes such as squares and triangles and giving them curved sides (in particular, **spherical triangles**). The patterns subvert the clarity of Early English bar tracery, for example by inserting an extra light between sub-arches, or placing two sets of arches of different type – for example, a tall lancet arch enclosing a lower

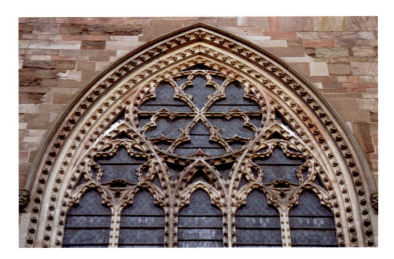

A lavish Geometrical Decorated window at Leominster Priory, Herefordshire, usually dated to the 1320s. The underlying idea of circlets separated by sub-arches is derived from that of early bar tracery, but an extra light separates the sub-arches from each other, and the circlets are filled with complex patterns of cusped stars and triangles. Ballflower covers everything.

ogee one – at the top of each light. Cusps become extremely elaborate: **split cusps** (a mouth-like opening with a cusp, most often seen in Kent), and sub-cusps (cusps within cusps, often seen thereafter), etc. One particularly common pattern, **intersecting tracery**, is diagnostic for Geometrical Decorated and sometimes seen in the second phase of the style, too. The aim in all these cases is to achieve effects of variety and surprise: in some memorable examples, such as Exeter Cathedral, each bay of the church has its own unique tracery designs.

Rose window-like designs often fill the main roundel of a window; though pure rose windows – circular windows filled with tracery – are rare in

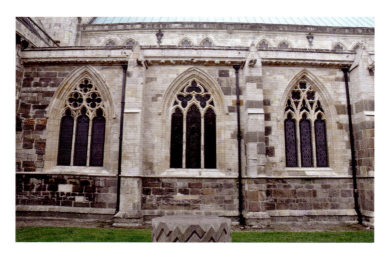

Late-thirteenth-century Geometrical tracery at Howden Minster, East Yorkshire, after c. 1267–72. Relatively subtle tricks – for example, removing the circlets that enclosed trefoils and quatrefoils, or making the central light slightly larger than the others – add a Decorated twist to bar tracery patterns.

GOTHIC II: DECORATED

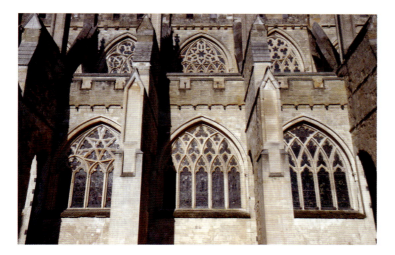

A grand display of Geometrical tracery at Exeter Cathedral. A variant on the intersecting window is seen at bottom right; that at bottom left has sub-arches supporting an enormous spherical triangle. The nave was begun in the 1320s and ogee curves can be seen in some of the clerestory windows.

England, and most (but not all) examples are Early English in date (circular windows without tracery, **oculi**, tend to be small and are usually Anglo-Saxon or Romanesque; or, with simple cusped patterns in them, Decorated).

Curvilinear tracery patterns are unmistakable, and diagnostic. From the 1310s, ogival curves – that is, the 'S' shape traced by one side of an ogee arch – begin to appear in windows. Designers used them to make the elements of a pattern flow into one another, resulting in a curvaceous effect that over the ensuing decade or two became the defining feature of tracery in general. One particular motif, the **mouchette** (and its straighter variant, the **dagger**), is used again and again, varying in size and precise arrangement. Again, now with a flickering, flowing, organic quality, variety is the aim. Sometimes, Geometrical and Curvilinear windows are seen side by side (or, later, Perpendicular and Curvilinear, though after 1400 Curvilinear patterns are usually only comparatively small elements in Perpendicular windows). One particular Curvilinear pattern is particularly diagnostic: called **reticulated**, it fills the entire window-head with a single, symmetrical, repeated motif, in effect a honeycomb based on ogees rather than hexagons.

Decorated foliage, too, falls into two phases of development. In the 1260s and 70s stiff leaf gradually turns into something equally stylised, and equally divorced from anything seen in nature, but rather knobbly in quality, and often called **crinkly** or 'seaweed' foliage. The stalks or branches that support it are often less prominent than before: sometimes entire surfaces are covered with rippling expanses of it. By *c.* 1300 this kind of foliage had become universal, changing only subtly – mainly in how it is arranged – in the Perpendicular period (see pages 57 and 72). These carvings continue to have the potential to be inhabited by beasts, green men and other grotesques,

Top right: A Curvilinear window at Ducklington, Oxfordshire, probably c. 1320–40: ogee curves give a flowing quality to its tracery. Sub-arches divide the window into two halves. The areas of solid masonry in the uppermost motif carry sculpted statuary inside the building, a typically Decorated conceit.

Top far right: swooping mouchettes and daggers in a Curvilinear window of c. 1333 at Heckington, Lincolnshire.

Lower right: Reticulated tracery at Earls Barton, Northamptonshire. This pattern, usually dated to the 1330s and 40s, can be seen in a great many windows of the Curvilinear period, though rarely with the window-arch itself being ogee-shaped, as here.

Lower far right: This Curvilinear two-light window at North Elmham, Norfolk, follows the pattern set by its Early English predecessors (see pages 40–41), but replaces the foiled circle with a single reticulation, rising from ogee-topped lights.

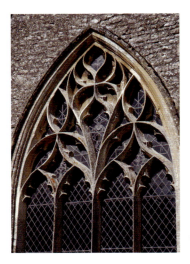

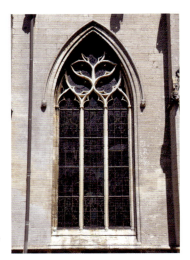

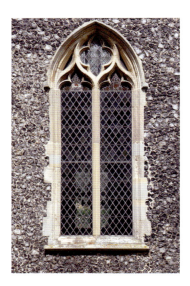

for which the Decorated era was a golden age. At the same time there is also a brief flowering of naturalistic foliage, in which individual species of plant, such as oak, maple and hawthorn, can be identified: indeed, this, along with the tracery patterns of the era, is the one motif that can truly be called diagnostic for Geometrical Decorated. At its very best, naturalistic foliage has clearly been carved directly from life: the chapter house at Southwell Minster (1288) contains the most famous examples. Both these types of

GOTHIC II: DECORATED

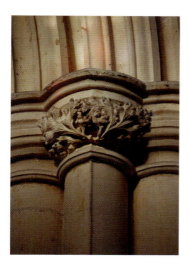 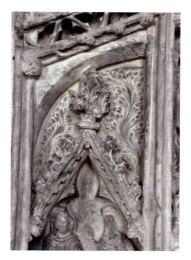

Far left: Two sprigs of crinkly foliage on a fourteenth-century capital at Beverley Minster.

Left: Lavish micro-architecture on the Easter sepulchre at Heckington. A fictive gable sprouts crockets and a finial of crinkly foliage, more of which spreads across the surface above.

foliage are widely used everywhere, for example on crockets, which are ubiquitous from now on.

In the Decorated era the capitals on which foliage is carved tend to shrink in size, and in the early fourteenth century begin often to be restricted to the shaft-like part of a column's moulding, allowing a **continuous moulding** to rise through to the arch above in Curvilinear Decorated and later, Perpendicular buildings. Sometimes the capital is a wide band at the top of the column; at others, there are simply no capitals at all, and the moulding swoops from the base of the column to the apex of the arch.

Such continuous mouldings existed in the West Country in the twelfth and thirteenth centuries, but are not seen elsewhere. They break the principle, previously fundamental, that capitals should emphatically divide a column from an arch. They thus embody some of the defining ideas behind Decorated mouldings. Geometrical mouldings are chiefly slightly flattened versions of their Early English predecessors, but from around 1300 mouldings tend to flatten and simplify, gaining a smooth quality rather akin to their

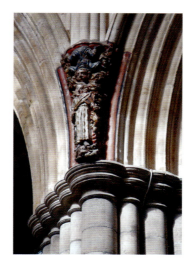

The bell capitals and emphatic shafts of this Geometrical Decorated pier at Exeter Cathedral are not dissimilar to those of the Early English style. But by bunching these features together, and subtly flattening the mouldings above, the designer has emphasised richness of effect and surface texture over clarity and linearity.

57

Small capitals clasp the diminutive shafts, while a great swoop of wave moulding runs continuously up the pier and into the arch. This pioneering design at Bristol Cathedral, possibly dated as early as 1298, also features unique vaults supported on bridges pierced by enormous mouchettes.

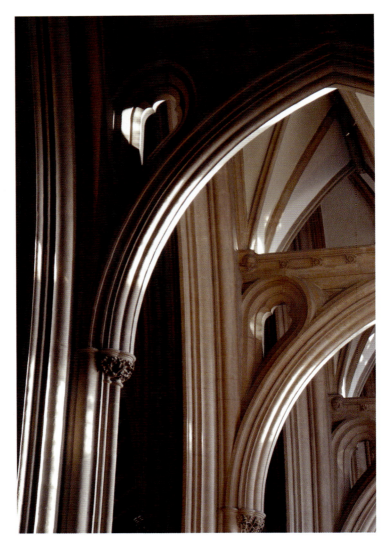

In the fourteenth century mouldings tend to get simpler and smoother, and ogee curves are introduced through the use of wave mouldings.

Perpendicular successors. An ogivally curving surface known as a **wave moulding**, very different from the complex forms of Early English and many Geometrical Decorated mouldings, is frequently used. The tendency to create separate *en-delit* shafts declined throughout the Geometrical Decorated period, too, and again after around 1300 almost disappears. Columns now read more as bundles of interconnected motifs than as arrangements of separate shafts. Though the shafting still roughly lines up with steps in the

GOTHIC II: DECORATED

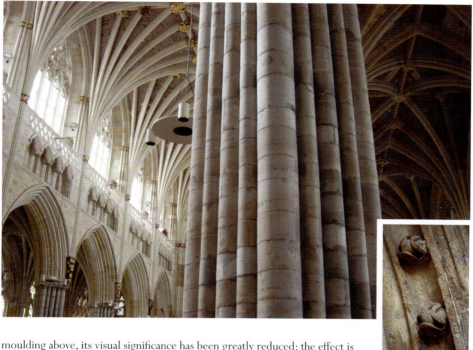

moulding above, its visual significance has been greatly reduced: the effect is to replace linear clarity with smooth dynamism.

In both phases of Decorated, variety is the watchword in other ornamental motifs. Nailhead and dogtooth, like stiff leaf and the repetitive patterns of early bar tracery, disappear rapidly in the 1260s–70s, and among a range of replacement motifs, most of them floral, is one that is highly diagnostic: **ballflower**, a ball-shaped fruit with a three-lobed mouth. This is seen occasionally in the 1280s–90s and becomes very widespread in the Curvilinear phase. It is repeated along mouldings and outside arches of all kinds, much as chevron and nailhead had been in previous stylistic phases; sometimes the ballflowers are joined by a curving foliate tendril; sometimes, especially in the Marches and west Midlands, they are simply dotted over entire surfaces, making some buildings appear as if they have caught a kind of architectural rash. Its obfuscatory, organic quality must have been profoundly ill-suited to the next style, and ballflower disappears rapidly from the mid-fourteenth century. In general the age in which it was created, the Decorated period, might have been in the mind of John Lydgate when he fantasised, in 1412–20, about architecture: 'So fresh, so rich, and so delightable, as it alone was incomparable.'

Above: Ballflower, a circular fruit-like motif with a three-lobed mouth that contains a smaller seed or fruit, at Bampton, Oxfordshire; probably early fourteenth century.

Top: Exeter Cathedral, rebuilt between the 1270s and the mid-fourteenth century, is a touchstone of Decorated design. Note the small triforium, which could never be confused with a gallery.

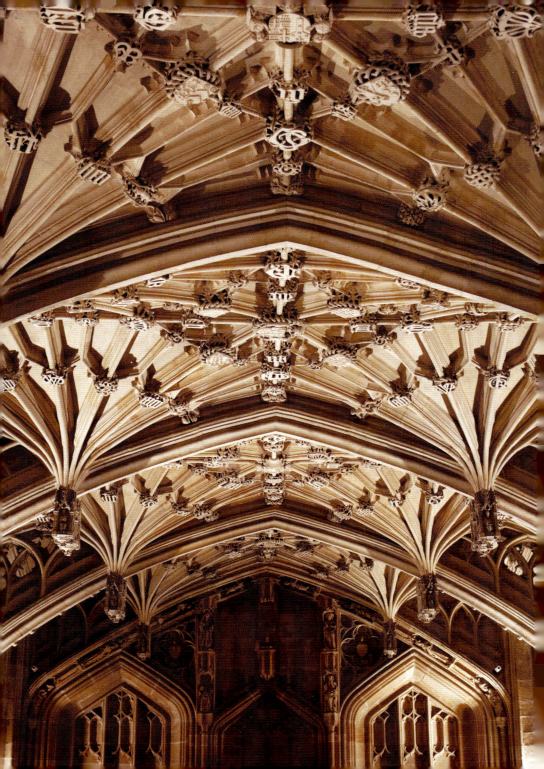

GOTHIC III: PERPENDICULAR

ALSO KNOWN AS RECTILINEAR; C. *1330–50 TO SIXTEENTH CENTURY*

Superficially, Perpendicular sits in marked contrast to Decorated. In effect, the sinuous ogival curve is replaced by the sobriety of the straight line; variety and inventiveness are replaced by repetition and a canonical set of stylistic rules almost as tight as those of Early English. Yet there are important continuities between the two.

A number of motifs seen in Perpendicular – the ogee arch, the lierne vault, the wave moulding and crinkly foliage have been mentioned, and there are also straight-topped windows and polygonal capitals (see pages 71 and 72) – were Decorated inventions. What Perpendicular does is to replace the capricious variety of Decorated design with a single, defining motif, applied with an unerring visual logic; everything from arch forms to capitals are adjusted to reflect its implications. As a result various once-popular motifs, such as ballflower, disappear, while the significance of others, such as the ogee arch, decreases markedly.

This motif, the panel (see page 65), brings visual unity to everything from the smallest fitting to the grandest church façade. It thus fulfils much that Decorated designers had striven for, while also reducing the number of one-off customised elements in a design. (Decorated at its height must have been very expensive to produce.) When seen from this point of view, Perpendicular is not so much a rejection of the licence of the Decorated era, an architecture going straight: it is a fulfilment of some of its most deeply desired aims, as if something restlessly searched for had finally been found.

Nevertheless, the lack of variety that results gives many Perpendicular buildings a sober, masculine, repetitive quality very unlike that of Decorated at its most exuberant: as it was put in 1540 of the parish churches of Nottingham, the style is 'excellent, new and uniform in work … [with] many fair windows'.

Opposite:
Tudor arches (in the three main blank arches) and pendant vaults at the Divinity School, Oxford (c.1423–83), a building that helped inspire a rebirth of architecture in the decades before the Reformation.

A grid of panels, rectilinear motifs derived from tracery, covers the tower at Cirencester, Gloucestershire (after c. 1400). If it were not for its arched head, the belfry window would simply be a continuation of the surface pattern that runs either side of it.

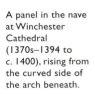

A panel in the nave at Winchester Cathedral (1370s–1394 to c. 1400), rising from the curved side of the arch beneath.

Its dependence on a single motif is only one of Perpendicular's unique characteristics. The style is long-lasting, which is another way of saying it is rather conservative: it is hard to distinguish a building of 1380 from one of 1480. Perpendicular is also uniquely English: for example, in Scotland and Ireland styles very close to contemporary French architecture (and to Curvilinear Decorated) predominated into the sixteenth century (see pages 11 and 13).

While a range of contextual factors may explain such qualities, including the traumas caused by the Black Death of 1348 and the relative isolation from French influence that was a result of the Hundred Years' War, it is true that European architecture in general fragmented into a series of distinct national styles during the fifteenth century. Historians generally think of the era from the mid-fourteenth to the sixteenth century as 'late medieval' and the Perpendicular style aligns perfectly with this important phase of social, political and cultural change: it is particularly relevant to church architecture that this saw the development of a deep, widespread and distinctive popular religious culture (see page 73), while a smaller group of people – the Lollards – for the first time publicly questioned some of the tenets of the traditional faith.

DEVELOPMENT

Perpendicular seems to have been consciously invented. This is a complex and fascinating story with its roots in the Decorated experiments associated with the royal court in the 1290s. For example, from this date there are occasional experiments with inserting short straight lines into the curves of window tracery patterns, and very occasional uses of new arch forms

in addition to the ogee – in particular, the **four-centred** arch. In addition to this, in one single (and lost) building, St Stephen's Chapel in the Palace of Westminster (1292), the window mullions are extended down the wall beneath each window, running blank over the wall surface, and then, like strings across an opening, continuing over the front of a lower set of windows.

Such innovations were ultimately inspired by contemporary French practice; they vividly embody the Decorated delight in delicious contrasts and the occlusion of structural clarity. But they were not as immediately influential as those other innovations of the 1290s, the ogee arch and the lierne vault. It is ironic that, in the longer term, they would result in an English architecture that was less interested in French precedent than any before, and the development of a style that moved away from obfuscation and variety and towards clarity and unity.

It is with the great experiments of the 1320s and 30s (see page 49) that these ideas are more fully explored. In particular, in two buildings of the same year, 1331–2, they come together to create an architecture in which straight lines are the watchword, extending over wall surfaces and transforming tracery patterns. These are the chapter house of Old St Paul's and the south transept (and, following on from it, the choir and north transept) at Gloucester Cathedral.

In both these buildings the straight line has been applied to window tracery to an extent previously unknown: it now becomes the defining idea of the pattern itself. For example, reticulations, which most other designers were forming from ogival curves, here become near-hexagons – Perpendicular reticulations. **Transoms**, hardly known in church windows before around 1300 (they are common in castles), become very emphatic, dividing the lower part of a window from the top, and giving it a grid-like aspect. Each light of the window beneath the transom is topped by a cusped arch, resulting in a row of rectilinear, arch-topped lights. A further row of these lights, each again topped by a cusped arch, is then carved on to the surface of the wall beneath, almost as if it were a blocked window – as

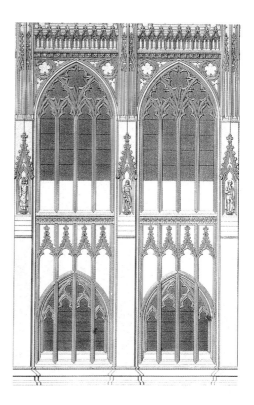

St Stephen's Chapel in the Palace of Westminster: an influential building, designed in 1292. Note the continuation of the mullions of the upper windows over the walls and windows beneath.

At Gloucester Cathedral (the choir, which refines the ideas used in the south transept of c. 1331–6, is shown here) the idea of continuing the window tracery over walls and surfaces is explored to spectacular effect. The grid-like effect that results is further emphasised by the straightening of the lines used in the window tracery and the emphatic transoms running across the window.

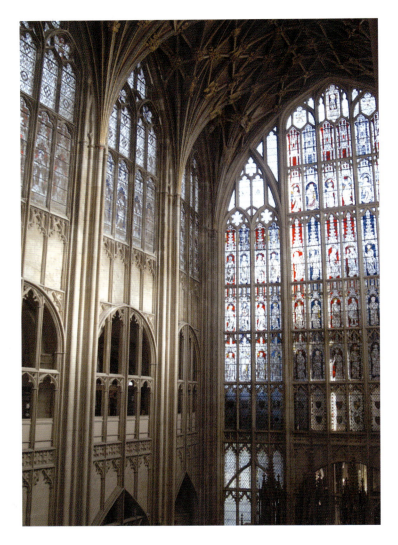

if the base of the window above was merely another transom. These motifs are panels; they turn the elevation into an extension of the window lights and unite the entire composition around their grid-like repetition. Other details, from arch forms to vaults, are flattened, emphasising rectilinearity wherever possible.

To many at the time, these buildings might have seemed little more than further contributions to a series of one-off experiments. Yet the extent to which they reinvent the formal details of architecture, and the

consistency of effect that results, had all the hallmarks of a new style. These were ideas that could be replicated and used in a wide variety of contexts.

At first the responses to this constitute an 'early Perpendicular', for example by adopting aspects of the new forms in otherwise conventionally Decorated settings. But in the 1350s and 60s, the architecture of Gloucester and Old St Paul's starts to be copied and finessed, and by the 1370s it has spread across southern England. Spectacular new naves at Winchester and Canterbury cathedrals cemented its success. By the 1380s Perpendicular is common in eastern and northern areas, too, though Curvilinear motifs long existed side by side with it in a manner rarely seen in the style's southern and south-western homeland. Well before 1400, it has simply become the only way to build, and would remain so for well over a century. In the later fifteenth century, however, the style develops a marked late phase, sometimes called Tudor, that can often be recognised, especially in vaults and arches (see page 61) and signs of **Renaissance** influence (page 77). The greatest of these buildings displayed a creativity and ornamental verve not seen since the 1330s.

The façade of the porch at Cirencester (c.1490–1500) is a handsome display of panelling.

DIAGNOSING PERPENDICULAR

The panel, as will already be clear, is the unmistakable diagnostic motif that lies at the heart of the Perpendicular style. Its origin lies in the shape of an individual window light. It is simply a shallow rectangle with a cusped arch in its head. Its rectilinear outline means it can be repeated to form a grid, which can be carved over any kind of surface, extending across windows and walls alike.

The motif is superficially like a niche, or even some of the pilaster strip patterns seen in Anglo-Saxon architecture, but can be straightforwardly distinguished from both. To function, a niche needs to be deep enough to hold a statue, whereas the panel itself is almost flat. Standing figures can be, and often were, painted in panels, but, to put a statue in one, a bracket or a canopy needs to be added to it. Anglo-Saxon pilaster strips are merely plank-like strips of stone, whereas panels, being derived from window

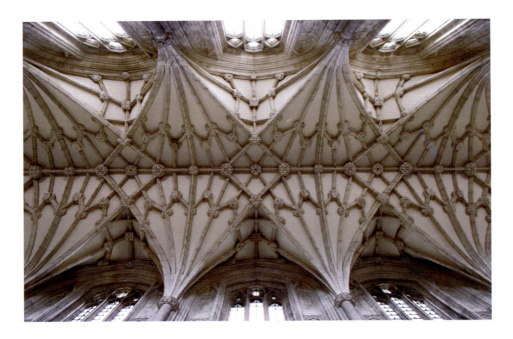

The vault in the nave at Winchester Cathedral (1370s–1394 to c. 1400) uses liernes to insert panel-like patterns between the tiercerons.

mullions, have simple but delicate mouldings, and the cusped arches in their heads are unknown in Anglo-Saxon architecture. Also, and again unlike pilaster strips, panels are not structurally separate from the surface into which they have been carved. Bearing in mind this single motif and its grid-like implications, we can explore the various other aspects of the Perpendicular style.

Lierne vaults are the commonest Perpendicular vault type. Designers often used them to evoke the idea of the panel, for example by using them to make extended, cusped shapes in their vaults, a form derived from window lights. However, the masons working on the cloisters at Gloucester (and perhaps a couple of other places) in the 1350s or 60s found a way of applying panels to vaults in a far more radical manner, known as a **fan vault**.

These vaults were constructed in a fundamentally new way. Instead of being made out of two separate elements – the groined infilling and the ribs – they are constructed as a single, curved skin built up in slabs so that it grows from the springing of the vault, very much like the cone of a trumpet. The result was a series of curved conoids, with small flat areas of ceiling where the conoids meet, structurally more akin to a dome or an igloo than a rib vault. The smooth surfaces of these conoids are carved with a series of panels, forming a pattern that spreads evenly out from the base; tracery

GOTHIC III: PERPENDICULAR

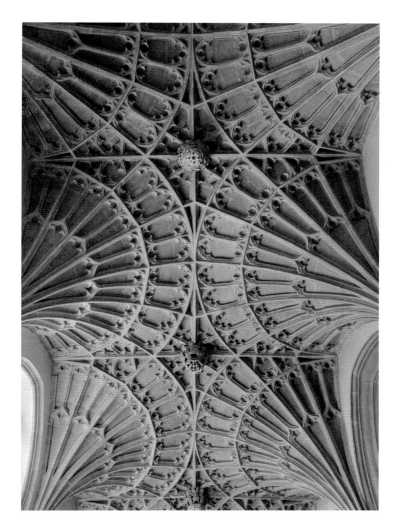

The true fan vault has no ribs or groins at all. Instead, panels are carved onto curving skins of stone. The geometrically ordered, almost mathematical quality that results is unmistakable, as seen here in the Lane Aisle (1526) at Cullompton, Devon.

patterns or perhaps a boss fill the flat areas between the conoids. Drawn as a plan, the carved panels are clearly derived from tracery patterns; indeed, they can be almost identical to those of earlier Gothic rose windows.

Fan vaults have an unerring smoothness, a kind of geometricality, that is both beautiful and distinctive. Unlike tierceron or lierne vaults, with which they are most often confused, there are no groins and no structural distinctions between rib and infilling, merely a single, smooth, curved surface bearing a carved pattern of panels. This effect is unmistakable, so much so that even when the same effect is contrived in a vault that is visually

67

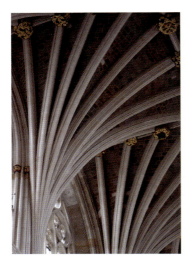

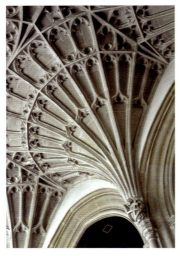

The difference between tierceron (upper, at Exeter Cathedral) and fan (lower, at Cullompton) vaults is clear when they are seen side by side.

identical to true fan vaults but *does* have separate ribs and infillings (as can be seen at Christ Church Cathedral, Oxford, and Sherborne Abbey, Dorset), such vaults are usually called fan vaults, too.

The fan vault is diagnostic for Perpendicular. It is also restricted to relatively intimate locations – aisles, cloisters, chantry chapels – and to south west England until the mid-fifteenth century. Indeed, true fan vaults (Sherborne is earlier but is not structurally a fan vault) were not placed over the main spaces of churches until around 1500, at King's College Chapel, Cambridge, for example, and such fan vaults help mark out late or Tudor Perpendicular from the rest of the style. At Christ Church, Oxford, and at Henry VII's Chapel, Westminster Abbey, the fans have become freestanding stalactite-like features, hanging down from the ceiling, and carved into **pendants**: though few such vaults in their pure form exist, roofs of other kinds, including timber ones, can have prominent pendants and are again diagnostic for Perpendicular in its late phase.

The designers of arches strove to translate the new thinking to ways of covering openings. The emphasis is now on ways in which the curved outline of an arch can be given a rectilinear aspect. The most diagnostic of these is the flattened, shouldered profile of the four-centred arch. This is so called because it is drawn by putting one's compass down four times (see page 82): parts of the arcs of two separate small circles give the arch its pronounced shoulders; then two much larger intersecting circles, struck from a much lower point, are used to bridge the gap between them. These arcs sometimes barely appear to be curved at all. This type of arch is seen very occasionally in the experiments of the 1290s to the 1330s, but it then takes over: very few Perpendicular buildings do not have some. A logical extension of this is for the shoulders to be made of extremely small circles, and the rest of the arch to be composed simply of straight lines, a motif called the **Tudor arch**, diagnostic for Perpendicular and particularly common from the later fifteenth century and into the sixteenth. It is quite different from the triangular arches of the Anglo-Saxon era, which are steep triangles, made of unmoulded stone, and contain no curves of any kind. Depressed arches are common in Perpendicular buildings, and much broader and flatter in profile than before, while a new and diagnostic variant, the **three-centred arch**, appears: both these developments again serve to de-

emphasise the arch's curvature. Finally, arches of all kinds, whether they be ogee, four-centred or of another form, and especially those over doors and tombs, are very often placed in rectilinear frames, formed of **drip-moulds** (the moulded lip that often runs round the outside of a window arch, previously a rather utilitarian feature). These had usually followed the curve of the arched window or door itself; now they become prominent, square, moulded frames, making the opening as a whole akin to the top of a large panel. Again, the motif emphasises the rectilinear and is highly diagnostic.

Two motifs, one really only a widened version of the other, are the key to understanding Perpendicular window tracery. The largest of these, the Perpendicular reticulation, is rarely a true hexagon: though it has straight sides, its top and bottom are usually slightly curved. It is used to generate a limited range of diagnostic patterns that must exist in their thousands in churches large and small across the country.

Four-centred arch in a square frame over a door at Tattershall, Lincolnshire (from 1469). The mullions of the window above rise continuously up to the window-arch.

Very commonly, one sees three-light windows with two reticulations in the window-head. Four-light windows might still be divided into pairs by sub-arches, but now have a Perpendicular reticulation above each pair of lights. The straight sides of these reticulations run upwards through the sub-arches and become the sides of a further reticulation in the window-head, before striking the arch of the window-head itself, as if the foiled circles in the bar tracery of the 1240s had been drawn with a ruler rather than a compass (see pages 41, 70). Indeed, the presence of a straight line in a window that runs throughout the tracery pattern (whatever the pattern itself is), from the top of a window light to the arch of the window-head itself, is also, wherever it occurs, diagnostic.

In these patterns each reticulation may be filled with a pair of small, glazed panel-like motifs. While the three-light and four-light variants described above (with or without paired, panel-like subdivisions of their reticulation units) are seen everywhere, these smaller units can also be used to generate tracery patterns in their own right: they play a key role in the larger and more varied Perpendicular tracery patterns. The most elaborate of these can have a lace-like quality. Spectacular east windows at Gloucester and York Minster, both comparatively early in the style, are often claimed to be among the largest medieval windows in Europe; Perpendicular churches in general can be large, airy cages of glass, their aisles lit by repeated tracery patterns.

There are some very simple forms of Perpendicular window. One is the style's updating of the triple-light window (see page 38), most easily distinguishable from its Decorated predecessor by its use of four-centred,

The three-light window on the right, at Avebury, Wiltshire, features what is probably the commonest Perpendicular tracery pattern of all: a pair of Perpendicular reticulations, each filled with two small panel-like motifs. The porch on the left is also Perpendicular, a four-centred arch topped by an emphatic drip-mould that ends in big, square label stops.

depressed or three-centred arches. Even simpler, and very illustrative of the Perpendicular mindset, are flat-topped windows. These usually comprise simply a row of panel-shaped lights, sometimes with paired panel-like motifs above each light. Such windows become increasingly commonplace in the fifteenth and sixteenth centuries. They are almost diagnostic, but, if the top of the light is a lancet arch or has a Curvilinear reticulation above it, it is probably Decorated; and, if the top of the light is an equilateral or ogee arch, one should check for other clues. Nevertheless, Perpendicular flat-topped windows with emphatic drip-moulds, their tracery a simple row

The windows to the left and right here feature a typical pattern for four-light Perpendicular windows, in which the straight sides of the reticulations cross the sub-arches, stopping at the window-arch. The walls here, at St Mary Magdalene, Launceston, Cornwall (1511–24), are covered with a riot of panelling, carved from intractable granite.

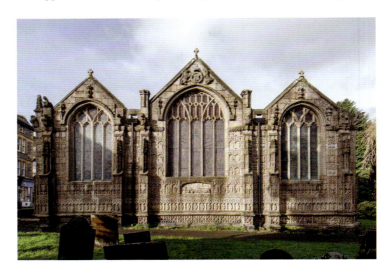

GOTHIC III: PERPENDICULAR

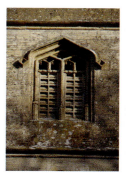 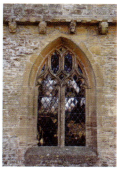 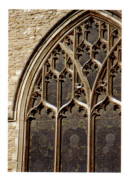

Far left: An emphatic drip-mould and a Tudor arch at Elkstone, Gloucestershire; fifteenth or sixteenth century.

Middle: Two-light windows are given a Perpendicular character by straightening the sides of the reticulation and placing within it a pair of small panel-like features. Elkstone; probably fifteenth century.

Left: A grand Perpendicular west window in the tower at Blakeney, Norfolk. Creativity in Perpendicular window design is usually focused on windows in the western and eastern walls of a church.

of glazed panels with four-centred or, later, semicircular tops, are ubiquitous in churches and domestic buildings alike.

Perpendicular foliage remains knobbly in character, if often rather stiff, like dried seaweed; very often it is clear the plant depicted is a stylised grapevine. It is the way this foliage is arranged that sets it apart most clearly from that of the Curvilinear Decorated era. It often runs in thin horizontal rows, which can be seen ranged one above the other; often, too, an 'S'-shaped tendril or branch links the leaves or fruits either side of its curves, or the leaves spiral around a central branch. The arrangement of foliage into such bands is seen in countless buildings, and is equally ubiquitous in timber roofs, screens and other furnishings; it is diagnostic for Perpendicular.

Capitals also show continuity with their late Decorated predecessors. Look out for capitals in which these horizontal foliage bands feature, or in which some or all of the moulding is polygonal rather than curved in plan: straight lines again. The latter are a Decorated invention, so one has to look for other motifs to be certain of their date. In general, Perpendicular mouldings tend towards smoothness, in a manner rather similar to their Curvilinear Decorated predecessors, and continuous and wave mouldings continue to be used. A couple of specific mouldings for columns, ultimately descended from compound piers, are diagnostic, and seen in countless buildings.

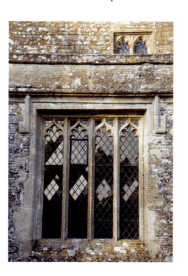

These Perpendicular flat-topped windows at Ogbourne St George, Wiltshire, simply comprise a row of tracery lights, like a row of glazed panels. The four-light lower window also has an emphatic hood-mould.

Dry-looking crinkly foliage, arranged in piled-up horizontal rows, on the rood screen at Cullompton, Devon.

The design of this column at Arundel, West Sussex (1380), follows a moulding pattern that was used in many churches over some two hundred years (see below): four attached shafts are separated by scoops; only the shafts have capitals (here they almost touch), leaving the scoop as a continuous moulding. Here, each bell capital has a polygonal abacus.

Perpendicular columns also have exceptionally high bases, making them more straightforwardly diagnostic than the bases of preceding styles.

More Perpendicular fittings survive than those of any other style: medieval timber roofs (such as the famous **hammerbeam** roofs, diagnostic, and popular in eastern England), doors, screens, pulpits, pews, sets of choir stalls or, more rarely, stone **reredoses** can be found (the only fittings earlier than this to survive in any number are tombs, fonts, Easter sepulchres, piscinas and sedilia). The scale of this survival is partly a reflection of the fact that this is both the most recent and the most long-lived of styles, but is also a vivid illustration of the nature of late medieval piety. At this time ordinary people invested large amounts of their disposable income in religious activities, creating a rich popular religious culture, intensely focused on preparation for death and on prayers for the souls of the dead, who were believed to be held in Purgatory. Huge numbers of parish churches were rebuilt or modernised by pious donors, and new fittings proliferated.

One type of fitting, invented in the 1360s, is a testament to this, and by definition Perpendicular: this is the **cage chantry**, at its simplest merely a panelled rectilinear enclosure of timber or stone inserted into an existing building, though the most elaborate are almost small churches in their own right. A chantry need not be held in a purpose-built chapel: it is simply a type of mass, one focused on the soul of a particular named individual or individuals. All that is needed is time at an altar for certain periods of the day. Structures of various kinds had for some time been created as venues for these masses, usually accompanied by a tomb. Now this specific invention, a

rectilinear panelled cage or screen inserted into a church, and containing an altar and a tomb, became the venue for the more lavishly endowed of these masses. The cage chantry is a reminder of the intense importance of commemorative prayer in this era, and an illuminating example of the Perpendicular aesthetic. Both a fitting and architecture, cage chantries are among the most richly creative designs of the late medieval period.

Late medieval religious culture also had a specific impact on Perpendicular art and imagery, resulting in the development of incidental sculpted motifs that do not occur at any other period and are thus diagnostic. Shields bearing chivalrous coats of arms, for example, had been carved on walls and tombs or depicted in stained glass windows in churches since the mid-thirteenth century, but now they proliferated, and developed a range of distinctive features. Perpendicular shields are often held by a sculpted angel. They may bear the *Arma Christi*, emblematic depictions of the wounds of Christ or the implements used to inflict them. They may also bear an inscription, a **merchant's mark** (in effect a logo) or a **rebus**, a punning representation of the name of the person who is being commemorated. Such features may be used in other decorative contexts, such as on roofs, where choirs of angels often bear them. Some tombs are grisly **cadaver effigies**, depicting the individual after death rather than before. All these motifs are designed to encourage pious reactions: prayers for the soul of a dead individual, empathy for the suffering of Christ, meditations on mortality.

All such fittings take on the language of the style, though some aspects of their micro-architecture, especially the canopies placed over niches or stalls, can be almost indistinguishable from those of the Decorated era.

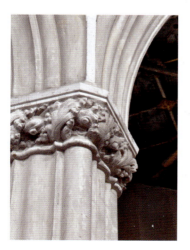

Left: This fifteenth- or sixteenth-century capital at Cullompton features a horizontal line of crinkly foliage, which runs in a spiral around a knobbly branch. The pier beneath has a type of wave moulding between its attached shafts.

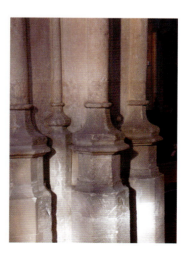

Right: A typically high Perpendicular column base with polygonal mouldings at Cirencester. It may have been designed to be visible above timber pews, which became popular for the first time in the late medieval era. Before this, church naves were largely free of fittings, apart from a font and side-altars; sometimes a stone bench ran around the walls.

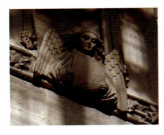

Right: A Perpendicular shield-holding angel set against a horizontal string-course made of spirals of crinkly foliage, at St Mary, Oxford (c. 1485–95). The angel, carved with a handsome fullness typical of the fifteenth century, may have displayed the arms of a sponsoring family or institution, or religious emblems such as the *Arma Christi*.

Far right: These owls at Exeter Cathedral stud the walls of the chantry chapel of Bishop Oldham (died 1519). The design of his rebus suggests that the bishop's name was pronounced 'Owl-dam', as it still is in his native Lancashire.

These niches at Burford, Oxfordshire (c. 1450), are capped by tall canopies that, taken in isolation, would be indistinguishable from those of the Decorated style. It is their setting in the midst of a tight pattern of rectilinear panelling that places them in the Perpendicular era.

Canopies that have been placed in a panel or a squared frame, or given emphatically flattened tops, are Perpendicular: everywhere, the panel can be applied with equal felicity to an entire building or to a small fitting such as a font or pew.

Perpendicular has very pronounced regional characteristics, especially visible in the austere granite churches of Cornwall and west Devon; in the bell towers of Somerset, the belfry windows of which become the centrepieces of enormous panel-like compositions, while their pinnacles and battlements dissolve into lacy crowns of pierced stonework; and in the **flushwork** popular in East Anglia, in which panels, tracery patterns, inscriptions and other motifs cut from honey-white limestone are filled with the grey-blue glow of knapped flints. Another source of rich-looking textures was alabaster, a kind of gypsum, used for altarpieces (and, more rarely, effigies). These were produced in huge quantities by workshops in Nottinghamshire.

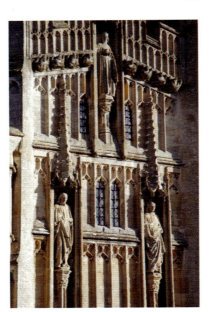

Finally, one might also argue that the style sees some attempts to play with the defining features that, for three hundred years, had gone to set great churches apart: such buildings as St George's Chapel, Windsor, and King's College Chapel, Cambridge, can be read as attempts to create distinctive variants on the great church specific to the collegiate communities that were developed on a previously unmatched scale at this period. In greater and

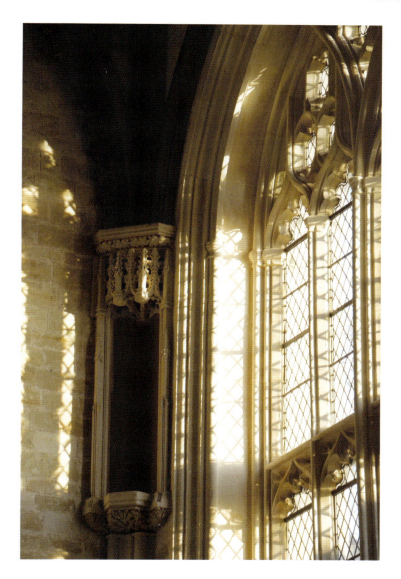

Left: This niche, in the chapter house at Exeter Cathedral (after 1413) has a typically Perpendicular flat-topped profile.

lesser churches alike, panelling often fills the space between the clerestory and the arcade, in great churches reducing the triforium to a bare minimum, and in lesser ones bringing a level of complexity to parish-church elevations that had previously been unknown. The clear distinction between greater- and lesser-church elevations was thus reduced, though it by no means disappeared.

MEDIEVAL CHURCH ARCHITECTURE

Right: The simple granite vernacular of Cornish/west Devon Perpendicular at Zennor, Cornwall.

Far right: Panelling rendered in flushwork at Lavenham, Suffolk (1525).

The elevation of the nave at Lavenham: panel-like blank tracery patterns are used to create a composition whose refinement and complexity would, at any other period, be exceptional in parish-church architecture.

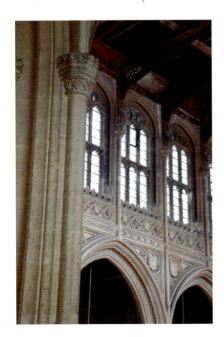

THE END OF GOTHIC

We have already mentioned a few features, such as Tudor arches, massive fan vaults and pendants (see pages 60 and 68) that are particularly associated with the last phase of Perpendicular. Though many of these features can be seen as early as the 1430s, it is at the end of the period that they become popular and architecture rediscovers something of the inventiveness and ornamental verve seen in the Decorated era. These late motifs are joined in the first decades of the sixteenth century by an infusion of motifs from Continental Europe, seen almost exclusively in timber fittings, some perhaps produced by itinerant foreign carpenters. Flamboyant, flickering tracery forms appear, hard to distinguish from (much rarer) Curvilinear-era timber fittings, but often accompanied by carved motifs of Renaissance origin, by now circulating in printed engravings: putti, little cherubs quite unlike hieratic Gothic angels; curving arrangements of vine and acanthus leaves. It may also be Renaissance influence that leads, for the first time in three hundred years, to a slight return for semicircular arches. Usually these curves have a depressed form rather than being pure semicircles, in window tracery and architecture alike; they rarely play a dominant role in a composition.

All this becomes increasingly common in the 1520s and 30s, reminding us that Gothic church

architecture would have continued to evolve had the complex processes of Reformation, starting with the Dissolution of the Monasteries in 1536 and 1539, but taking a series of twists and turns over many decades, not transformed the whole pattern of building in general. This era, of course, saw the separation of the Protestant and Catholic churches, the destruction of medieval shrines, the reduction of many monasteries to ruins, and, from 1547, systematic iconoclasm.

The story thereafter is a fascinating one, but can only be sketched out here in the briefest form. The weight of architectural investment and invention shifts rapidly following the Dissolution from churches to country houses; for example, no new great church was built in England until St Paul's Cathedral was rebuilt in the 1660s. Before this, the details used in Elizabethan and Jacobean church fittings have a distinctive, Renaissance-influenced flavour, though church architecture itself, where it exists, is often a simple version of late Perpendicular practice, perhaps with a few Classical details thrown in. Fittings changed, reflecting new thinking about the faith itself. For many, the altar was no longer seen as sacramental: it was merely a table. A new emphasis on the sermon resulted in prominent pulpits. It is not until the late seventeenth century that a pure and fully understood Renaissance style first becomes the norm in English architecture; to recognise this, one has to be familiar with the many diagnostic elements of Classical architecture,

Above: Renaissance putti and other Classical motifs cavort along the edge of a late Perpendicular tomb recess at Exeter Cathedral.

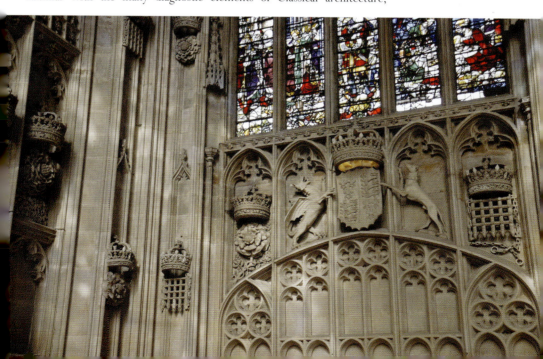

Previous page, bottom: The lavish late Perpendicular completion of King's College Chapel, Cambridge, from 1508 has a swaggering richness, its panelling studded with Tudor heraldic motifs.

including its rules of proportion and composition, and the capitals and other diagnostic details used in the Doric, Tuscan, Ionic, Composite and Corinthian orders. From now on church buildings are more frequently seen, successively Baroque and Neo-Classical in style, depending on period; increasingly in the eighteenth century, some loosely evoke medieval designs: this 'Gothick' is easy to distinguish from the real thing, but it is worth remembering that it is at this period that people first began to take an interest in an architectural form that had long been derided for its association with Catholicism. The term 'Gothic' is a post-medieval coining, associating the style with the 'barbarian' despoilers of Classical Rome.

Then, from the early nineteenth century, and running right into the twentieth century, serious archaeological interest in medieval architecture flowers, alongside a movement known as Historicism, in which older styles of architecture are revived. The Gothic Revival was a major development within this: here, medieval architectural styles were applied to everything from railway stations to the new churches of the industrial towns and suburbs. At the same time the widespread 'restoration' of ancient churches to their 'pure' medieval form has created a challenge for modern architectural historians. Indeed, it should be emphasised that almost all statues, wall paintings, stained glass windows, monuments, pulpits and pews, and most roofs and screens, in churches today are Victorian or later.

Some Gothic Revival work is easy to recognise because it mixes up motifs of different medieval eras or borrows them accurately but unhistorically from outside England – chiefly from Italy or France. But in other places restoration is nearly impossible to tell from original work: without a pre-restoration illustration, a given motif may look suspiciously 'clean' or machine-cut in its detailing, but determining whether it is an accurately recut medieval original, an inaccurately but convincingly recut medieval original or a complete invention may not be straightforward. Better clues come in any associated sculpted imagery and stained glass: if statues have heads, and windows are not comprised of a mosaic of black lines caused by centuries of fixing and re-fixing, they are probably Victorian. In all these cases, the Victorians rarely depicted figures, especially faces, in quite the stylised, hieratic way that was the norm in the medieval period: a kind of realism in modelling and features, under the influence both of the Renaissance and of photography, is diagnostic once the eye has learnt to identify it. Today, it is impossible to get permission to make changes to the fabric of churches that are indistinguishable from older work, though they must be in sympathy with it.

The realism and fine finish of the nineteenth-century re-carving (above) separates it from a more stylised and worn thirteenth-century original (below) at Cirencester.

POSTSCRIPT

In retrospect, the flavour of each of these styles is unmistakable: the muscular articulacy of Romanesque, with its ranks of shafts and semicircular arches; the clarity and linearity of Early English, with its noble arrangements of single-light windows; the variety and ornamentalism of Decorated, with its palm-tree tierceron vaults and rich tracery patterns, and then, in the fourteenth century, its flickering quality based on ogee curves and lierne vaults; the regularity and rectilinearity of Perpendicular. Features such as Anglo-Saxon strapwork; the Norman cushion capital; chevron and early rib vaults; Early English stepped lancets; stiff leaf, nailhead and dogtooth; Decorated reticulations; naturalistic foliage and ballflower; and the Perpendicular panel and fan vault are easy to recognise: they might have been invented for the benefit of future architectural historians. The date of many structures can be established by learning these alone.

Each of these styles has its own claim to greatness. The muscular grandeur and clarity of Romanesque is unmistakable; it was now that the framework of elaborately composed bays and high stone vaults was developed which would remain at the core of medieval architecture thereafter. During the Transitional period an extraordinary aesthetic transformation took place as masons explored a new idiom of pointed arches and colossal openings. This, Gothic, was developed with a restless energy for three centuries: Early English speaks with remarkable elegance and eloquence; Decorated brings with it a radical spirit of experiment and sense of theatre; and Perpendicular generates a rich range of architectural effects from a single defining motif, and in doing so fulfils many of the aims sought in previous centuries.

There is much to learn simply by studying the formal way in which these styles changed and developed. But can we reach beyond this, to inhabit the imaginative world of the men who created them? Medieval masons would not have recognised our stylistic categories; their ultimate aim was to create a suitable setting for a rich array of images in glass, paint and stone, and a magnificent backdrop to a grand and sacred

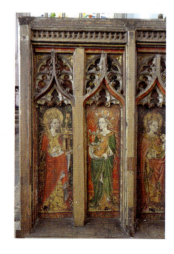

Perpendicular panels were eminently suited to the depiction of rows of standing saintly figures, as seen here on the sixteenth-century rood screen at North Elmham, Norfolk. It is easy to underestimate the significance of such requirements to the development of architectural style.

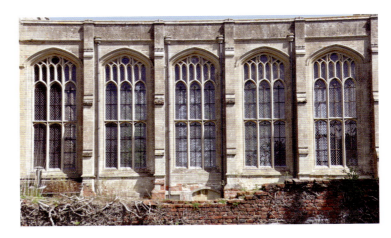

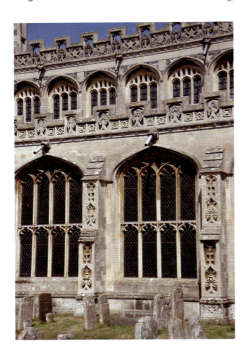

The end of architecture? The cages of glass of the Perpendicular era, originally packed with coloured images, seen here at Tattershall (right) and Lavenham (below), fulfilled many of the aims that designers had sought for centuries.

liturgy. Architecture combined with other arts, and the rites themselves, to create a richly sensual experience, replete with significance to all who witnessed it: a hymn of praise to God, and, for humanity, a glimpse of heaven itself. A brief such as this is sufficient to inspire constant creativity.

Such concerns might have influenced the development of architectural detail in all kinds of ways: as just one example, the creation of ever larger and more elaborate windows is a major theme throughout our story; perhaps, then, it was the power of stained glass images that was uppermost in designers' minds. Stylistic phases might simply be a by-product of such concerns. In any case it is striking how periods of comparative stylistic stasis, in which a kind of architectural hegemony has developed (Early English and Perpendicular), alternate with phases of rapid evolution and experiment (Romanesque/Transitional and Decorated). Why should these patterns occur, and to what extent do they reflect trends in wider society, whether they be religious, intellectual or historical? It is with such questions, which lack definitive answers but which matter all the more for their unanswerability, that the study of style blurs into the study of history, and architecture becomes a window on a wider past.

POSTSCRIPT

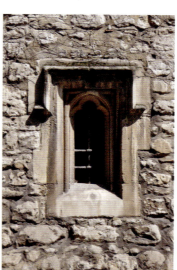

Clockwise from top: Norman, Early English (lancet), Decorated and Perpendicular single-light windows at Duntisbourne Rouse, Gloucestershire, and (bottom right) Westminster Abbey.

GLOSSARY

Abacus: moulded feature marking the top of a capital.
Aisle: subsidiary space running alongside a central vessel or transept.
Ambulatory: an aisle that runs behind the high altar.

MEDIEVAL CHURCH ARCHITECTURE

Anglo-Saxon: architectural style prevalent before the Norman Conquest.
Apse: structure with a semicircular or polygonal plan, usually containing an altar.
Arcade: row of columns topped by arches.
Arch: opening topped by a curve.
Arma Christi: coats of arms bearing the wounds of Christ or the implements used to inflict them.
Attached shaft: thin half-column, structurally part of a wall or a compound pier. See page 20.
Ballflower: decorative motif, a ball-shaped fruit with a three-lobed mouth. See page 59.
Baluster: short supporting column. See page 14.
Bars: thin pieces of stone, used to create tracery.
Base: moulded feature at the foot of a column.
Basilican: a common form for a church – a central vessel with aisles, typically lit by a clerestory and with an apse at one end.
Bastard groin: vault where the groins wobble.
Bay: a single arch in an arcade, and any window or architectural composition associated with it.
Beakhead: a decorative motif featuring a row of bird-like heads whose long, thin beaks reach out over to the moulding of the arch or column beneath them, as if biting it. See page 24.
Bell capital: smoothly curved capital, with an abacus of clumped mouldings at the top. See page 42.
Blank arcade: row of arches against a flat wall. In its mature, Romanesque form, it is constructed identically to a true arcade, but is entirely decorative in nature. See pages 18 and 52.
Boss: carving masking the intersection of ribs.
Buttress: stone structure, usually vertical, helping to support a wall
Cadaver effigy: sculpted image of the deceased as a corpse.
Cage chantry: box-like purpose-built chapel for chantry masses (see page 73), typically containing an altar and a tomb.

Some major types of arch. Left to right: semicircular arch, equilateral pointed arch, lancet pointed arch, ogee pointed arch, four-centred pointed arch.

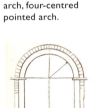
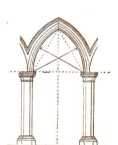
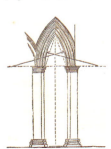
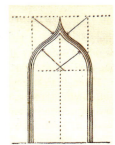
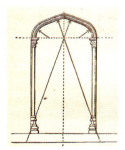

GLOSSARY

Capital: feature separating a column or pier from the arch above.

Cathedral: a church that is the seat of a bishop.

Central vessel: the main space of a church, in great churches usually comprising nave, crossing, choir and presbytery; in lesser churches, nave and chancel.

Chancel: the space in a lesser church that holds the high altar. The *sanctuary* is the area containing the altar itself (see *Presbytery*).

Chevet: side-chapels arranged fan-like around an apsidal east end. This arrangement was common in Romanesque great churches everywhere and in its Gothic form, to which the term is most usually applied, remained standard on the Continent. Only a handful of examples of either period survive in England. Gothic chevets are more likely than Romanesque ones to have polygonal apses.

Chevron: zigzag-shaped decorative motif. See pages 23–25.

Choir: the part of a great-church east end in which singers sit during services; immediately west of the presbytery, and often indistinguishable from it architecturally.

Cinquefoil: decorative motif in which five cusps sit within a circle.

Clerestory: windows above an arcade, lighting the central vessel.

Collegiate church: church served by a residential community of priests (as long as the priests are not also monks, in which case the church is a monastery).

Column: single vertical support, usually circular or sometimes polygonal.

Compound pier: column of complex form, usually including attached shafts.

Continuous moulding: runs from the ground, or the base, of a column to the tip of the arch without interruption by a capital.

Corbel table: if an upper level or parapet of a building steps outwards, becoming wider than the structure beneath, it is often carried on a row of small stone supports. These are corbels, and a row of them is a corbel table.

Crinkly foliage: rippling, knobbly, tightly detailed, stylised type of foliage; also known as 'seaweed', especially when rather dry and stiff-looking. See pages 57 and 72.

Crocket: sprout-like motif emerging from the side of a gable. See pages 39 and 53.

Crossing: space where a transept crosses the main vessel, usually with a tower above.

Cross-ribs: the ribs on a vault that follow its groin.

Cruciform: cross-shaped.

Crypt: subterranean or semi-subterranean space.

Curvilinear: second phase of Decorated: lierne vaults and ogee arches.

Cusps on a monument at Boxgrove Priory, West Sussex.

Cushion capital: capital having four sides, each with a single scallop. See page 24.
Cusp: decorative feature made up of a series of arcs, commonly seen in window tracery, arches, etc.
Dagger: teardrop-shaped tracery motif. See page 56.
Decorated (Dec): middle period of Gothic architecture, here c. 1260 to c. 1350–70 (see page 65).
Depressed arch: pointed arch struck from centres that are further apart than those used to create an equilateral arch.
Dogtooth: decorative motif, like nailhead but with the sides carved away, leaving four thin, petal-like forms with straight sides, joining at a sharp apex. See page 45.
Drip-mould: moulding that runs around the outside of an arch and directs water away from it.
Early Gothic: alternative name for Transitional, especially where the style is clearly Gothic but has yet to settle into Early English.
Early English (EE): first mature period of Gothic architecture, here c. 1190–1200 to c. 1260.
East end: the arm of a church containing the high altar.
Easter sepulchre: a recess on the north side of the high altar, used to symbolise the tomb of Christ in Easter liturgies.
Elevation: one vertical segment of an interior.
***En-delit* shaft:** especially slim shaft, physically separate from any column or wall. See page 43.
Equilateral arch: pointed arch with sides of equal dimensions. See page 82.
Façade: major facing wall, often elaborately designed.
Fan vault: vault comprised of trumpet-shaped conoids with panel patterns on them. See page 67.
Feretory: the part of an east end containing a saint's shrine. Its location varies, but is often behind the high altar, immediately east of the presbytery or in a retrochoir.
Flushwork: tracery-like limestone patterns filled with knapped flint. See page 76.
Flying buttress: arch outside a building, transferring some of the thrust of a vault or roof to the outer wall of an aisle.

GLOSSARY

Four-centred arch: arch with a shouldered profile. See pages 60 and 82.

Gallery: large middle storey of an elevation; an upper aisle, fronted by arches. See page 32.

Geometrical: the first phase of Decorated; also used to describe window tracery of Early English type and its Geometrical Decorated derivatives.

Gothic: architecture of pointed arches and enormous openings, invented in the twelfth century.

Great church: church having the architectural attributes appropriate to cathedrals and greater collegiate and monastic churches. See pages 9–12.

Groin vault: vault formed by two interpenetrating tunnels. The corner formed where the tunnels intersect is the *groin*. See page 22.

Hammerbeam: horizontal timber in a roof, reaching out into open space and supported on arched braces; further arched or vertical timbers, or even a second hammerbeam, rise from it.

High altar: the main altar of a church.

Hyphenated chevron: a decorative motif consisting of zigzag ornament alternating with straight sections of moulding.

Intersecting tracery: tracery pattern in which the line of the arched top of each light continues into the head of the window, creating a series of parallel curves that run across each other.

Keystone: wedge-shaped stone at the apex of a true arch, locking it into place.

Lady Chapel: important side-chapel, dedicated to St Mary, often in a great church east of the high altar, or in a lesser church in the north aisle. See page 8.

Lancet arch: an arch significantly higher than it is thin. See pages 36 and 82.

Lancet window: simple, single window with a lancet or equilateral-arched head. Though they are different things, both lancet windows and lancet arches are often called simply 'lancets'. See page 81.

Lesser church: term used in this book for churches having the simpler architectural attributes of parish and other churches of lower status than great churches.

Lierne rib: short vault rib, connecting or interrupting cross-ribs, ridge ribs or tiercerons.

Lierne vault: vault containing lierne ribs. See pages 51 and 86.

Lights: vertical segments into which the lower part of a traceried window is divided by mullions.

Long-and-short work: corners lined by emphatic horizontal and vertical stones. See page 14.

Merchant's mark: graphic device used as an emblem of a specific merchant, for accounting and branding purposes alike.

Micro-architecture: elaborate sculpted fantasy architecture, used for example on a Gothic canopy over a niche, tomb or high-status seat.

Monastic church: church served by a residential community of monks (a *nunnery* is for nuns). Divided into *abbeys* and subordinate smaller *priories*. Some monks, but usually not all, may also be priests.

Mouchette: asymmetrical tracery motif in which a dagger curves to one side; see page 56.

Moulding: cross-section of a shaped stone.

Mullion: vertical rib, separating the lights of a window.

Nailhead: decorative motif comprising repeated small pyramid-shaped forms. See page 34.

Nave: the western part of the central vessel of a church, to which lay people usually had free access.

Niche: recess for a statue.

Nodding ogee: ogee arch that curves outwards into space. See page 53.

Norman: English Romanesque style, also called *Anglo-Norman*, c. 1070 to c. 1170–80.

Oculus: circular window, sometimes with simple cusping but no tracery. The plural is *oculi*.

Ogee arch: arch composed of two opposed 'S' curves. See pages 52, 82.

Order: some openings have several columns ranged either side of them, each apparently supporting a different moulding in the arch above. In medieval architecture, each of these arch-and-column combinations is called an order. In Classical architecture, an order is something different: a canon of rules for architecture, in which the detailing of bases, columns, capitals and upper parts is divided into five different groups.

Panel: decorative motif, a blank rectangle with a cusped arch at the top. See page 62.

Parish church: church in a local community, served by a priest; typically a lesser church.

Pendant: decorative motif that hangs down from a ceiling.

Perpendicular (Perp): third period of Gothic architecture, c. 1330–50 to the sixteenth century.

Pier: support comprising a complex arrangement of mouldings, columns and/or shafts.

Pilaster strips: decorative arrangements of plank-like pieces of stone. See page 14.

Piscina: basin for the priest to ritually wash his hands before Mass, and into which to rinse out the mass vessels afterwards. Always adjacent to an altar, usually on its south side. See page 33.

Plate tracery: separate windows arranged in a pattern within a blank arch. See page 40.

GLOSSARY

Porticus: Anglo-Saxon porch-like transept.

Presbytery: the part of the east end of a great church that contains the high altar. Not always architecturally distinguishable from the choir.

Pulpitum: solid screen with a central doorway, marking the western entrance to a choir.

Quatrefoil: decorative motif in which four lobes sit within a circle (see pages 40, 54 and elsewhere). The most common of the cusped circles (see *Trefoil*, *Cinquefoil*).

Rebus: punning visual representation of a name.

Renaissance: European rediscovery of Classical learning and culture, visible in the visual arts from the fifteenth century onwards.

Rere-arch: an arch on the inner wall of a window. See page 39.

Reredos: decorative screen, rising behind an altar.

Reticulation: symmetrical tracery motif, like a cell of a honeycomb, but with ogee-curved sides (if it has straight sides, it is a *Perpendicular reticulation*).

Retrochoir: open area in the east end of a great church, behind, that is to the east of, a high altar.

Rib vault: vault in which the groined ceiling is enriched by thin cross-arches, *ribs*. See page 23.

Ridge rib: rib that follows the apex of a vault. See page 50.

Romanesque: architectural style emerging in the eleventh century, in England usually called Norman. Once used for all architecture in western Europe between the fall of Rome and the Gothic era.

Rood: scene of the Crucifixion with St Mary and St John the Evangelist either side of the cross. There was usually a rood screen beneath it. In a lesser church, rood and rood screen separated nave from east end, almost filling the chancel arch, if there was one; in a great church, they stood to the west of the pulpitum.

Rose window: a circular window containing tracery. See *Oculus*.

Sanctuary: area immediately around the high altar; in a great church also known as the presbytery.

Scallop: flat-sided motif with a curved base on the side of a cushion capital.

Sedilia: ceremonial seats for officiants, on the south side of an altar. They are often combined with a piscina. See page 33.

Sexpartite vault: a cross-vault in which the bays are paired.

Shaft: slim column, playing a subsidiary function rather than providing support.

Shaft-ring: slim horizontal moulding on a shaft. See page 43.

Spherical triangle: triangle with curved sides.

Split cusp: cusp broken by a narrow, mouth-like opening, particularly common in Kent.

Stepped lancets: lancet windows arranged in a stepped row of three or more.
Stiff-leaf foliage: three-lobed, with a long stalk. See page 44.
String-course: horizontal moulding, usually marking the edge of a level in an elevation.
Sub-arch: tracery arch, subdividing a window.
Sub-cusp: cusp which it itself cusped.
Three-centred arch: arch struck from three centres, low-slung and not pointed.
Tierceron rib: runs parallel to the cross-ribs, from the springing of a vault to its apex.
Tierceron vault: contains tiercerons and no liernes. See page 50.
Tracery: pattern of thin bars in the arched part of a window.
Transept: north–south arm of a church.
Transitional: phase of architecture when Gothic ideas are emerging, *c.* 1160 to *c.* 1190–1200.
Transom: horizontal bar across the lights of a window. See page 64.
Trefoil: decorative motif in which three lobes sit within a circle.
Triforium: an attic-space middle storey, fronted by arches. See page 32.
Trumpet scallop: a curving scallop. See page 30.
Tudor arch: low, straight-sided pointed arch. See page 60.
Tunnel vault: the simplest type of vault. Its section may be semicircular or a type of pointed arch.
Tympanum: space between an arch and a horizontal feature such as a door lintel (below the arch) or a string-course (above it).
Vault: ceiling with a curved surface, usually constructed of stone.
Volute: abstract leaf-like motif, curling as it supports the abacus of a capital.
Voussoirs: wedge-shaped stones that comprise a true arch.
Waterholding moulding: moulding with the form of a dip or scoop.
Waterleaf capital: capital with smooth-sided leaves and tiny volutes. See page 30.
Wave moulding: moulding that, in cross-section, has the form of a wave or an ogee curve. See page 58.
West front: important façade at the western end of a church.
Wind-blown stiff leaf: stiff-leaf foliage carved to appear as if it is being shaken by a strong wind.

FURTHER READING

The works marked with an asterisk* are indispensable.

Alexander, Jonathan, and Binski, Paul (editors). *Age of Chivalry: Art in Plantagenet England, 1200–1400*. Royal Academy of Arts, 1987.
Binski, Paul. *Becket's Crown: Art and Imagination in Gothic England, 1170–1300*. Yale University Press, 2004. Explains the intellectual and imaginative mindset underlying the artistic achievements of the era.
Bony, Jean. *The English Decorated Style*. Phaidon, 1979. Out of print, but an essential discussion.
Cannon, Jon. *Cathedral: The Great English Cathedrals and the World that Made Them*. Constable, 2007. Places these great churches in their context.
Coldstream, Nicola. *The Decorated Style*. British Museum Press, 1994.
Draper, Peter. *The Formation of English Gothic*. Yale University Press, 2006. Up-to-date discussion of Early English.
Fernie, Eric. *The Architecture of Norman England*. Oxford University Press, 2000.
Harvey, John. *The Perpendicular Style*. Batsford, 1978. Out of print, but the most recent detailed analysis of this style.
Jenkins, Simon. *A Thousand Best Churches*. Penguin, 1999.
Looking at Buildings (http://www.lookingatbuildings.org.uk/index.html)
Marks, Richard, and Williamson, Paul (editors). *Gothic: Art for England, 1400–1547*. Victoria and Albert Museum, 2003.
Morris, Richard. *Churches in the Landscape*, Phoenix, 1990 edition. For an archaeological 'landscape' perspective.
*Pevsner, Sir Nikolaus, and others. *Buildings of England* county guides (and, latterly, city guides). Yale University Press, various dates.
*Rodwell, Warwick. *The Archaeology of the English Church*. Alan Sutton, revised edition 2012.
Taylor, H. M., and Taylor, Joan. *Anglo-Saxon Architecture* (three volumes). Cambridge University Press, 1965 onwards. Out of print, but an essential discussion.
Webb, Geoffrey *Architecture in Britain: The Middle Ages* Penguin (Pelican History of Art,) 1956. Out of print, and out of date in some details, but still an essential overview.
*Wilson, Christopher. *The Gothic Cathedral*. Yale University Press, 1992. A defining, Europe-wide overview of architectural development, revealing much about how masons developed and analysed detail.

PLACES TO VISIT

Sites are selected for their diagnostic potential, especially where surviving fittings or glass give a fuller picture. Beauty and originality are not given as much weight as usefulness for learning to distinguish styles. A single asterisk* by the name of the style denotes that the example is particularly instructive; two asterisks ** indicate buildings that have become famous as 'textbook' examples of a given style. Dedication of churches is not given where the main Church of England parish church in a settlement is being cited.

Bedfordshire: Felmersham (EE).

Berkshire: Eton College Chapel (Perp). Padworth (Norm*). Shottesbrooke (Dec*). Windsor Castle: St George's Chapel (Perp**).

Bristol: Bristol Cathedral (Norm* chapter house; EE* Elder Lady Chapel; Dec* east end). Bristol: St Mary Redcliffe (Perp*; Dec* outer north porch).

Buckinghamshire: Chetwode (EE). Hillesden (Perp). Stewkley (Norm).

Cambridgeshire: Barnack (AS* tower). Cambridge: King's College Chapel (Perp**). Cambridge: Round Church (Norm). Ely Cathedral (Norm** transepts and nave; EE** east end; Dec** Octagon, Lady Chapel). Peterborough Cathedral (Norm*; EE* west front; Perp* retrochoir).

Cheshire: Nantwich (Dec/Perp).

Cornwall: Altarnun (Perp, with screen and pew-ends). Launceston: St Mary Magdalene (Perp*).

Cumbria: Carlisle Cathedral (Norm and Dec*).

Derbyshire: Melbourne (Norm*). Tideswell (Dec* and Perp).

Devon: Cullompton (Perp*, with roofs and screens). Exeter Cathedral (Dec** with fittings; Norm* towers). Hartland (Perp, with screen and bench-ends). Torbryan (Perp, with screen and glass).

Dorset: Sherborne Abbey (AS, Norm, Perp*). Studland (Norm). Whitchurch Canonicorum (Trans and EE, with shrine).

Durham: Durham Cathedral (Norm**; Transitional** Galilee; EE** Chapel of the Nine Altars; Perp** towers). Escomb (AS*).

Essex: Saffron Walden (Perp*). Thaxted (Perp, with reredos). Waltham Abbey (Norm).

Gloucestershire: Deerhurst (AS**). Fairford (Perp, with stained glass). Gloucester Cathedral (Perp* transepts, choir, cloister, Lady Chapel, tower). Northleach (Perp**).

Greater Manchester: Manchester Cathedral (Perp*, with choir stalls).

Hampshire: Breamore (AS). Portchester (Norm). Portsmouth Cathedral (EE). Romsey Abbey (Norm*). Winchester Cathedral (Norm* transepts; Perp* nave). Winchester: St Cross Hospital (Norm/Transitional*).

Herefordshire: Abbey Dore (EE). Hereford Cathedral (Dec* north transept). Kilpeck (Norm*).

Hertfordshire: Hemel Hempstead (Norm). St Albans Cathedral (Norm* nave and transepts; Dec* Lady Chapel).

Kent: Barfreston (Norm*). Canterbury Cathedral (Norm* crypt; Transitional/EE* east end with stained glass; Perp* nave, funerary monuments). Chartham (Dec*). Dover: St Mary in Castro (AS). Hythe (EE). Maidstone (Perp). Stone (EE*).

Lancashire: Lancaster (Perp).

Leicestershire: Gaddesby (Dec).

Lincolnshire: Barton-upon-Humber: St Peter (AS and later). Heckington (Dec**). Kirkstead: St Leonard (EE). Lincoln Cathedral (EE*/Dec). Tattershall (Perp*).

London: St Bartholomew-the-Great, Smithfield (Norm*). St Etheldreda's, Ely Place, Holborn (Dec). Temple Church (Transitional* nave; EE* east end). Westminster Abbey (EE*; Perp* Henry VII's Chapel).

Merseyside: Bebington (Perp). Sefton (Perp, with various fittings).

Norfolk: Cley next the Sea (Dec*). King's Lynn: St Nicholas (Perp, with roofs, fittings). Norwich Cathedral (Norm**; Dec/Perp cloister). Norwich: St Peter Mancroft (Perp*, with various fittings). Salle (Perp*, with various fittings). Snettisham (Dec*). Terrington St Clement (Perp*). West Walton (EE**).

Northamptonshire: Brixworth (AS*). Earls Barton (AS** tower). Northampton: St Peter (Norm).

Northumberland: Hexham Abbey (EE*).

Nottinghamshire: Nottingham: St Mary (Perp). Southwell Minster (Norm* nave; EE* east end; Dec* chapter house, screen).

Oxfordshire: Bloxham (Dec). Ewelme (Perp*, with almshouse/school, fittings, paint and monument). Iffley (Norm** with later changes). Uffington (EE).

Rutland: Tickencote (Norm).

Shropshire: Heath Chapel (Norm).

Somerset: Bath Abbey (Perp**). Crewkerne (Perp). Glastonbury Abbey (Transitional Lady Chapel). Taunton: St Mary Magdalene (Perp*, especially tower). Wells Cathedral (Trans/EE** nave, west front; Dec** chapter house, Lady Chapel, glass and fittings). Yeovil (Perp, with font, lectern).

Staffordshire: Lichfield Cathedral (EE* chapter house, nave; Dec* Lady Chapel).

Suffolk: Blythburgh (Perp). Lavenham (Perp**, with screens and chantry chapels). Long Melford (Perp*, with glass and paint). Southwold (Perp).

Sussex (East and West): Winchelsea (Dec*). Worth (AS).

Warwickshire: Warwick: St Mary (Perp** Beauchamp Chapel, glass, sculpture, monuments and paint).

Wiltshire: Bradford-on-Avon: St Laurence (AS**). Devizes: St John (Norm* chancel). Edington (early Perp). Potterne (EE). Salisbury Cathedral (EE**). Steeple Ashton (Perp).

Worcestershire: Pershore Abbey (mostly EE). Worcester Cathedral (Norm* crypt; EE* east end).

Yorkshire (East Riding): Beverley Minster (EE* east end; Dec* Percy tomb). Patrington (Dec**).

Yorkshire (North): Selby Abbey (Dec* east end). Thirsk (Perp). York Minster (EE* transepts; Dec* nave and chapter house; Perp* east end, stained glass).

Yorkshire (West): Adel (Norm*).

Wales: Brecon Cathedral (Powys, EE chancel). Chepstow Priory (Monmouthshire, Norm). Clynnog Fawr (Gwynedd, Perp). Ewenny Priory (Bridgend, Norm). Gresford (Wrexham, Perp*, with fittings and glass). Holywell: well and church (Flintshire, Perp*). Kidwelly (Camarthenshire, Dec). Llandaff Cathedral (Cardiff, EE nave and west front). Margam Abbey (Neath Port Talbot, EE). Mold (Flintshire, Perp). Newport Cathedral (Gwent, Norm nave). St David's Cathedral (Pembrokeshire, Norm/Transitional nave; Perp Trinity Chapel).

APPENDIX: CHRONOLOGY OF STYLES

KEY FEATURES OF MEDIEVAL ARCHITECTURAL STYLE: A DIAGRAMATIC CHRONOLOGY

	1000	1100	1200	1300	1400	1500	1600
Arches							
Semicircular	--------	--------					
Pointed			--------	--------	--------	--------	--------
Lancet			--------				
Ogee				--------	--------		
Four-centred					--------	--------	--------
Vaults							
Groin	--------	--------					
Cross-rib		-------- (with pointed arches) --------	--------	--------	--------	--------	--------
Tierceron				--------	--------		
Lierne					--------	--------	
Fan					--------	--------	--------
Windows							
Semicircular-headed	--------	--------	--------				
Paired and stepped lancets			--------				
Plate tracery			--------				
Bar tracery				--------			
Other geometrical patterns				--------			
Curvilinear					--------		
Perpendicular					-------- (with polygonal abaci) --------	--------	--------
Foliage/capitals							
Cushion capitals		--------					
Waterleaf capitals		--------					
Bell capitals			-------- (in horizontal bands) --------	--------	--------	--------	--------
Stiff-leaf foliage			--------				
Naturalistic foliage				--------			
Crinkly foliage					--------	--------	
Other decorative motifs							
Chevron		--------					
Dogtooth & Nailhead			--------				
Ballflower				--------			
Panelling					--------	--------	--------
	NORMAN		EARLY ENGLISH	DECORATED	PERPENDICULAR		RENAISSANCE

INDEX

References to illustrations are in *italic*.

Aisles 7, 8, 11
Alabaster 74
Altar 12, 31, 77; *see also* High Altar
Anastasis of the Holy Sepulchre (Jerusalem) 21
Angels 73, *74*, 76
Angevins 19
Anglo-Saxon style 7, *14*, 15–17, 19, 66, 79
Apse 7, 16, 21, 32
Arcades 7, 9, *10*, 11, 16, 75
 Blank 27, 41, 44
 Norman *18*, 21, 22
Arches 4, 5, 9, *82*
 Anglo-Saxon 16, *16*, 17
 Depressed 35, 68
 Equilateral 35–6, 50–1, *82*
 Four-centred 63, 68, 69, *82*
 Lancet 36, *36*, 50
 Ogee 49, 51–2, *52*, 56, 61, 63, 79, *82*
 Pointed 27–30, *28*, 35, 36, 79, *82*
 Semicircular 19, 22, *26*, 27, 30, 76, 79, *82*
 Three-centred 68–9
 Tudor 60, 68, *71*, 76
 see also Rere-arches; Sub-arches
Arma Christi 73
Arundel (West Sussex) *72*
Avebury (Wilts) 70
Axial plan 6–7, *7*

Balusters 16, *16*
Bampton (Oxon) *38*, *59*
Bar tracery 38–9, 40, *40*, *41*, 47, 52, 54, *54*
Barnack (Cambs) *16*
Baroque style 78
Basilican plan 6, 7, 8, 16
Bastard groin 27
Bays 7, 19, 24, 27, 28–9, 79
Beauchamp Chapel (Warwick) *12*
Bell capitals 42, *57*
Berkswell (West Mids) *5*
Beverley Minster *52*, *57*
Bishops 9
Black Death 62
Blakeney (Norfolk) *71*

Bosses 22, 36
Boxgrove Priory (West Sussex) *39*, *43*, *84*
Bristol Cathedral *18*, *24*, *28*, 49, *58*
Brixworth monastery (Northants) 16
Building time scales 5
Buildings archaeology 5–6
Burford (Oxon) *74*
Buttresses 22, 28–9, 44, 47
Byzantine architecture 15

Cage chantry 72–3
Canopies 73, *74*
Canterbury Cathedral 41, 65
Capitals 12, 17, 24–5, *57*, *58*
 Bell 42, *57*
 Cushion 20, 23, *24*, 29, 79
 Norman *18*, 20
 Perpendicular 71, *73*
 Polygonal 61
 Scallop 23, *24*, 30–1
 Stiff leaf 42, 43, *44*, *45*, 55, 79
 Volute 23, *24*, 30, 42
 Waterleaf 30, *30*, 42
Carolingian style 15
Carvings 9, 23, 76, *78*
Cathedrals 5, 9, 11, 19–20
Central vessel 7
Chancel 7, 8, 11, *25*
Chapels 11
Chapter houses *41*, 63
Charlemagne 15
Chevet 21
Chichester Cathedral *26*
Choir 8, 21, *64*, 72
Christ Church Cathedral (Oxon) 68
Christ in Majesty *26*
Church plans 6–8, 21
Cinquefoils 38
Cirencester Cathedral *62*, *65*, *73*, *78*
Classical style 16, 23, 77–8
Clerestory windows 7, 9, *10*, 11, 75
Cley next the Sea (Norfolk) *10*
Collegiate churches 9, 74
Columns 7, 12, 16, 23
 Decorated 57, 58–9
 Early English 40–2, *42*, 43–4
 Perpendicular 71–2, *72*
Compound piers 23
Conoids 66–7

Cornwall 74, 76
Craft techniques 47
Crinkly foliage 55–6, *57*, 61, *72*, *73*
Crockets 44, 47, *57*, *57*
Crosses 17
Crossing 11, 21
Cross-ribs 22, 36, 49, *51*
Cruciform plan 6, 7, 7–8
Crypts 21, 22, 31
Cullompton (Devon) *13*, 67, *68*, *72*, *73*
Curvilinear style 47, 49, 50, *52*, 55, 65
Cushion capitals 20, 23, *24*, 29, 79
Cusps 38, *38*, *45*, 50, 54, 66, *84*

Dates 6
Decorated (Dec) style 4, *10*, 31, 35, 42, 47–52, 54–9, 61, 79, *81*
Decoration 12
Dendrochronology 6
Depressed arches 35, 68
Devon 74, 76
Dissolution of the Monasteries 77
Divinity School (Oxon) *60*
Doorways 21, 24, *24*, *33*, 36, 72
Dorchester Abbey (Oxon) 11, *48*
Drip-moulds 69, *71*
Ducklington (Oxon) *56*
Duntisbourne Rouse (Glos) *8*, *81*
Durham Cathedral 20, *20*, *23*, 27

Earls Barton (Northants) *16*, *56*
Early English (EE) style 4, 29, 30, 31, 35–44, 48–9, 79, *81*
Early Gothic style 27–33
East Anglia 74
East end 6, 10, 11, 16, 21, 31–3
Easter sepulchre 32–3, 72
Effigies 12, 73, *74*
Elevation 7, 9, *10*, 11, *24*, 31, *75*, *76*
Elizabethan style 77
Elkstone (Glos) *25*, *26*, *71*
Ely Cathedral (Cambs) 49, *52*
En-delit shafts 41, *42*, *43*, *58*
Equilateral arches 35–6, 50–1, *82*
Europe 13, 19, 49, 62, 76;
 see also France
Exeter Cathedral *48*, 49, *50*, 54, *55*, *57*, *59*, *68*, *74*, *75*, 77

94

Façades 10, 11, 22, 42, 44
Fan vaults 66–8, 67, 76, 79
Feretory 8
Fillets 43
Finials 47
Flint 74
Floral patterns 12
Flushwork 74
Flying buttresses 29
Foliage 4, 30, 36, 36, 42, 46, 76, 79
 carving 23
 Perpendicular 71
 see also Crinkly foliage
Fonts 12, 21, 72
Four-centred arches 63, 68, 69, 82
France 29, 48, 62, 63, 78
Funding 5

Gainsborough Old Hall (Lincs) 13
Galleries 9, 21, 31, 32
Gargoyles 47
Geometrical patterns 12
Geometrical style 47, 49, 50, 52, 55, 55
Geometrical tracery 40
Gloucester Cathedral 11–12, 32, 63, 64, 65, 66, 69
Gothic era 9, 24, 25, 78
 Transitional 27–33, 41, 44, 79
 see also Decorated; Early English; Perpendicular
Gothic Revival 78
Great churches 6, 8–11, 19–20, 21, 22, 31–3, 74–5
 Plan 7
Groin vaults 21–2, 22, 27, 36, 49
Grotesques 55

Hammerbeam roofs 72
Heckington (Lincs) 56, 57
High altar 6, 6, 8, 21, 33
Historicism 78
Howden Minster (East Yorks) 54
Hundred Years' War 62

Iconoclasm 12, 77
Iffley (Oxon) 20, 24
Île-de-France (Paris) 29, 48
India 51
Intersecting tracery 54
Ireland 13, 62
Isle of Purbeck (Dorset) 41
Italy 78

Jacobean style 77

Kilpeck church (Herefords) 21
King's College Chapel (Cambs) 68, 74, 77

Lady Chapel 8, 33, 52
Lancet arches 36, 36, 50
Lancet windows 37, 37, 39, 42
Lavenham (Suffolk) 76, 80
Leominster Priory (Herefords) 54
Lesser churches 11, 21, 31–3, 75
Lierne vaults 49, 50, 51, 61, 63, 66, 66, 67, 79
Limestone 41, 74
Lincoln Cathedral 10, 34, 36, 44, 44, 46, 49
Linearity 44
Location 6
Lollards 62
Long-and-short work 16
Lord Mayor's Chapel (Bristol) 33
Lydgate, John 59

Masons 4–5, 6, 11, 27–9, 79–80
 Decorated 52
 Norman 21, 22
Mass 32, 33
Merchant's mark 73
Micro-architecture 47–8, 52, 57, 73
Monasteries 19
Monastic churches 9
Monastic houses 11
Motifs 5, 6, 9, 19, 22, 30, 33
 Ballflower 59, 59, 61, 79
 Beakhead 24, 24
 Chevron 20, 23–4, 24, 29, 31, 42, 79
 Dagger 55, 56
 Dogtooth 42–3, 45, 59, 79
 Mouchette 55, 56
 Nailhead 31, 34, 42, 43, 59, 79
 Shields 73, 74
 Two-lights-and-a-circle 38
Mouldings 4, 9, 12, 17, 20, 22–3, 30, 36
 Continuous 57–8, 71
 Early English 42, 43, 45
 Perpendicular 71, 72, 73
 see also Drip-moulds; Wave moulding

Nave 7, 21, 65
Neo-Classical style 78

Newcastle Cathedral 11, 12
Niches 10, 12, 44, 47, 65, 74, 75
Nodding ogees 52, 53
Non-religious buildings 13
Norman Conquest 19
Norman style 5, 7, 18, 19–25, 27, 79, 81
North Elmham (Norfolk) 56, 79
Norwich Cathedral 20, 22, 24
Nottinghamshire 74
Nuns 9

Ogbourne St George (Wilts) 30, 44, 71
Ogee arches 49, 51–2, 52, 56, 61, 63, 79, 82
Ogival curves 55, 61
Old Minster (Winchester) 15
Old St Paul's (London) 63, 65
Orders 23

Paintwork 12, 47
Palace of Westminster 49, 63, 63
Panelling 48, 61, 62, 64, 65–6, 70, 75, 76, 77, 79, 79
Parish churches 5, 6, 8, 11, 61, 72
 Decorated 48
Pendant vaults 60, 68, 76
Perpendicular (Perp) style 4, 13, 49, 52, 55, 61–78, 79, 81
Peterborough Cathedral 20
Pews 72
Piers 22, 23, 41
Pilaster strips 16, 65, 66
Piscina 32, 33, 44, 72
Plantagenets 19
Plate tracery 37–40, 38, 40, 45
Pointed arches 27–30, 28, 35, 36, 79, 82
Polygonal plan 31
Porches 65, 70
Porticus 16
Portsmouth Garrison Church 38
Prague 49
Presbytery 8
Priests 9, 32
Pulpits 7, 21, 72, 77
Purbeck marble 41, 42, 43
Putti 76, 77

Quatrefoils 38, 40

Rebuilding 5
Rebus 73, *74*
Rectilinear plan 33
Rectilinear style *see*
 Perpendicular style
Reformation 77
Reims (France) 37
Religious culture 11, 62, 72, 73
Religious scenes 12
Renaissance style 65, 76, 77
Rere-arches 37, *39*, 44
Reredoses 72
Restoration 6, 78
Reticulated pattern 55, *56*, 63, 69, 79
Retrochoir 8, *26*
Rhineland (Germany) 23
Rib vaults 22, *23*, 27, 29, 31, 36, 79
Rickman, Thomas 4
Ridge ribs 36
Roman architecture 15, 30
Romanesque style 7, 19–25, 27, 29, 41, 44, 79
Rood 12
Rose windows 54–5, 67

Saint-Denis Abbey (Paris) 29
St George's Chapel (Windsor) 74
St Mary (Oxon) *74*
St Mary, Barton-upon-Humber (Lincs) 30
St Mary, Ely (Cambs) *33*
St Mary Magdalene, Lauceston (Cornwall) 70
St Mary Redcliffe (Bristol) 11, *51*, 53
St Nicholas (Galway) *11*
St Paul's Cathedral 77
St Peter, Barton-upon-Humber (Lincs) *17*
St Stephen's Chapel, Palace of Westminster 63, *63*
Sainte Chapelle (Paris) 48
Salisbury Cathedral *32*, 36, *39*, *41*, 42
Sanctuary 7, 8
Saxo-Norman overlap 21
Scallop capital 23, *24*, 30–1
Scotland 13, 62
Screens 7, *7*, 12, *13*, 72, 79
Sculpture 12, 17, 47
Sedilia 32, 44, 47, *48*, 72

Semicircular arches 19, 22, *26*, 27, 30, 76, 79, *82*
Shaft-rings 41
Shafts 9, *20*, 22–3, 24, 41–2, 58–9, 79
Sherborne Abbey (Dorset) 68
Side-chapels 8, 21
Somerset 74
Southwell Minster (Notts) 56
Spherical triangles 52
Stained glass 12, 47, 78, 80
Statues 44, 65, 78
Stepped lancets 37, 38, *38*, *39*, 40, 79
Stiff leaf capital 42, 43, *44*, *45*, 55, 79
Strapwork 79
Stratigraphy 6
Styles 4–5, 6, 13, 79–80
Sub-arches 39, 40, *54*, 69

Tattershall (Lincs) *69*, 80
Temple Church (London) 11, *37*
Three-centred arches 68–9
Tierceron ribs 49–50, *51*
Tierceron vaults 35, 47, 49–50, *50*, 67, *68*, 79
Tilework 47
Timber 6, *13*, 72, 76
Tombs 12, 44, 47, 72, 73
Towers 9, 10, 11, 31
Tracery 4, 35, 55, *55*, 66–7, 79
 Perpendicular 63–4, *64*, 69
 see also Bar tracery; Plate tracery
Transepts 7–8, 21
Transoms 63–4
Transubstantiation 33
Trefoils 38
Triforium 9, 31, *32*, *45*, *59*, 75
Trumpet scallop *30*, 30–1
Tudor arches 60, 68, *71*, 76
Tudor style 65
Tympanum 24, *25*

Vaults 4, 9, *10*, 11, 19, 24
Early English 36
Sexpartite 31 *see also* Fan vaults; Groin vaults; Lierne vaults; Pendant vaults; Rib vaults; Tierceron vaults
Victorians 6, 78
Volute capital 23, *24*, 30, 42

Wales 13
Walls 5, 15, 29
Waterholding mouldings 43–4
Waterleaf capital 30, *30*, 42
Wave moulding 58, *58*, 61, 71
Weightlessness 30, 40, 44
Wells Cathedral 49, 50
West Country 30, 49, 57
West front 7, 10
West Walton (Norfolk) *38*, *40*
Westminster Abbey 49, 68, *81*
Westworks 31
Whitewash 12
Winchester Cathedral 15, *24*, *62*, 65, 66
Windows 5, *5*, *11*, *13*, 29–30, *54*, 55, 79, 80, *81*
 Anglo-Saxon *14*, 16, *16*
 Clerestory 7, 9, *10*, 11, 75
 Decorated 48, *56*
 Lancet 37, *37*, *39*, 42
 Norman 21, 22
 Perpendicular 63–4, 69–71, *71*
 Rose 54–5, 67
 Straight-topped 61
 see also Tracery
Wooden architecture 15
Worcester Cathedral *28*
Worship 31

York Minster 9, 37, *45*, 69

Zennor (Cornwall) 76